LACKAWANNA COUNTY
CHRONICLES

LACKAWANNA COUNTY
CHRONICLES

Margo L. Azzarelli

THE
History
PRESS

Published by The History Press
Charleston, SC 29403
www.historypress.net

Images are courtesy of the Lackawanna Historical Society, unless otherwise noted.

First published 2015

Manufactured in the United States

ISBN 978.1.62619.761.9

Library of Congress Control Number: 2014954500

Notice: The information in this book is true and complete to the best of our knowledge. It is offered without guarantee on the part of the author or The History Press. The author and The History Press disclaim all liability in connection with the use of this book.

"Good night, Emma. See you in the morning."

You are in our hearts forever!

CONTENTS

ACKNOWLEDGEMENTS

I wish to thank everyone who helped with this labor of love, especially Josh B.; *Our Town Lackawanna County* for giving me a medium to preserve the county's history; the Lackawanna Historical Society; Cheryl Kashuba; Charles Kumpas; Hannah Cassilly; and pioneer historians Dr. Horace Hollister, Dr. Benjamin H. Throop, Thomas Murphy, Reverend Samuel C. Logan and Frederick L. Hitchcock.

Also, without the love and support of my family and friends, nothing would be possible. Marnie xoxoxo!!!

INTRODUCTION

This work is a collection of articles on Lackawanna County's history that have been published bimonthly in *Our Town Lackawanna County*.

Its story began in 1878, when the county was formed, after having broken away from Luzerne's Government. But its history began long before that, when the Munsee Indian chief Capoose occupied a portion of the Lackawanna Valley.

Originally, what is today Lackawanna County was in the Westmoreland colony of Connecticut or later Northumberland County, Pennsylvania. The Decree of Trenton gave this portion of land entirely to Pennsylvania. When Connecticut settlers attempted to make it a new state, the people of Pennsylvania countered in 1786 by creating Luzerne County out of Northumberland and "extending from Nescopeck Falls, to the northern boundary of the state." At the time, it contained what is now Lackawanna, Susquehanna, Wyoming, Columbia, Lycoming, nearly all of Bradford and sections of Montour and Sullivan Counties.

Except for Lackawanna, there was little opposition in creating the other counties out of Luzerne. Then, finally, after many attempts, Pennsylvania governor John F. Hartranft issued a proclamation dated August 13, 1878, declaring the establishment of the new county of Lackawanna.

Take a journey in time and read about many of Lackawanna County's firsts, including the people who made their mark in the county's history and events that changed the past and paved the way for the future. Yesterday, today and tomorrow, Lackawanna County is history in the making.

THE MAKING OF A COUNTY

ITS GENESIS

Before the spring of 1878, many bills seeking the creation of our present county had been introduced in the state legislature, but unfortunately, all were met with defeat. During a meeting with the Scranton bar, an act was drawn up providing for the birth of new counties, and on April 17, 1878, it became a law. That same year, a special election was held on August 13. Out of 11,601 votes that were cast, 9,615 were in favor of the new county and only 1,986 opposed it. A proclamation by Pennsylvania governor John F. Hartranft, dated August 13, 1878, declared the establishment of Lackawanna County. People celebrated the victory in a manner that would not be soon forgotten. Lackawanna Avenue was lit up from end to end, and hundreds of residents went from house to house singing and shouting with joy; bells rang, bonfires roared and the sound of cannons thundered through the air.

By virtue of the powers conferred under the act of April 17, the following men were named as officers of Lackawanna County:

- Horace F. Barrett, Henry L. Gaige and Dennis Tierney—County Commissioners
- Frederick L. Hitchcock—Prothonotary

- A.B. Stevens—Sheriff
- J.R. Thomas—Clerk of the Courts
- E.J. Lynett—Auditor
- J.L. Lee—Register of Wills
- F.W. Gunster—District Attorney
- Miner Renshaw—Recorder
- William N. Monies—Treasurer

Before the upper end (as it was called) became Lackawanna County, every deed recorded or mortgage entered, every step that led up to a trial, be it criminal or civil, meant a trip to Wilkes-Barre. In the 1860s, there was only one train per day running each way. It left Scranton at 6:00 a.m. and did not return until 6:00 p.m. The new county had been an absolute necessity.

On September 3, 1878, the newly elected commissioners accepted the offer of Addison Sweetzer for the use of the second and third floors of his building located on the corner of Lackawanna and Penn Avenues, known as Washington Hall, for court purposes. The premises of Hunt Brothers and Company was used as a jail. Ground for a new courthouse would not be broken until April 14, 1881.

During a celebration honoring the fiftieth anniversary of Lackawanna County, held at the Hotel Casey in October 1928, Commissioner Morgan Thomas ended his speech with the following:

> *What will our county be tomorrow? It will be something more than it is today. Something better. Something finer. The life breathed into it by its people is what the county is and always will be. If the people are courageous, the county is courageous. If the people are tolerant and loving, the county will be tolerant and loving. The county can be no bigger or better than its inhabitants.*

CARBONDALE

Carbondale, the "Pioneer City," was chartered on March 15, 1851, fifteen years before Scranton, making it the oldest city in the county. The Wurts brothers, William and Maurice, began its coal mining industry there when the city was still nothing more than a wilderness with fewer than a dozen inhabitants. William is credited for giving the city its name. According to

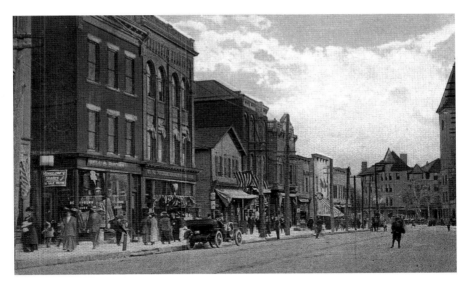

North Main Street in Carbondale, also known as the "Pioneer City."

historian Dr. Horace Hollister, the name results from the combination of the carbon found in the dale by the Wurts brothers in 1822. Another source claims that Carbondale was named by the famous novelist and historian Washington Irving. It is believed that Mr. Irving became interested in the Delaware and Hudson Canal Company and for several years was on its board of managers. The Honorable Terrence. V. Powderly stated that Carbondale was first called "Barrendale" due to its barren vista. He first heard this claim from his father, and the statement was later verified by James M. Poore, one of Carbondale's early settlers.

David Alsworth, a native of Rhode Island, is believed to be Carbondale's first settler in 1802. Other early settlers included Roswell B. Johnson, George Parker and Winley Skinner. These pioneers were concerned with earning a living in order to take care of their families; at the time, they were unaware of the treasure hidden beneath the ground in the form of anthracite coal.

At the beginning of their mining industry, the Wurts brothers centered their interest on the Philadelphia coal market and used the Delaware River as means of shipping. Unable to make a profit, they began to focus on the New York market. Once the Gravity Railroad was built, thereby solving the problem of shipping the coal, the industry and area of Carbondale flourished. In 1824, the Wurts brothers built a cabin for their home. It was known as the "Log Cabin." It also contained a tavern and store and quickly became the hub of the city's activity.

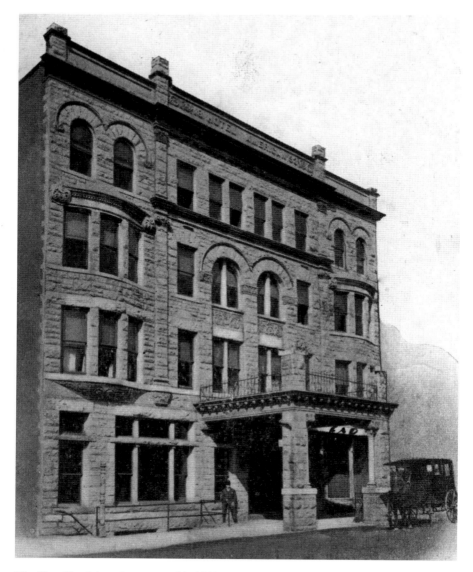

The New Hotel American opened in 1893.

By 1829, the town had a post office, a physician by the name of Dr. Thomas Sweet and its first lawyer, Dwight N. Lathrope. Ironically, both men had settled in Carbondale on the same day, and both died on the same day, October 8, 1872.

The Gravity Railroad and the Wurts brothers million-dollar mining operations took Carbondale from a small hamlet of a few hundred people

to a village of more than six hundred, with several stores and other establishments by the early 1830s.

In the 1850s, P.T. Barnum first brought his "caravan, museum, and menagerie" to the Pioneer City. General Tom Thumb was the featured attraction.

The Hotel American was located on North Main Street. Brothers Samuel H. Williams and John W. Williams tore down the hotel that was on the site in order to erect the Hotel American, which they operated until 1904.

Carbondale's first election was held on March 21, 1851. James Archbald, chief engineer for the Delaware and Hudson Railroad, was elected mayor. A wooden courthouse was built in 1852; it burned down on Valentine's Day in 1859. It was quickly replaced by a sturdy brick building, and Carbondale's city hall was established.

The Honorable Terrence V. Powderly, mayor of Scranton, was a native of the Pioneer City. Other notable natives include Joseph R. Sarnoski, Congressional Medal of Honor recipient due to service in World War II; Terry Pegula, owner of the NFL team the Buffalo Bills; and General Jerome F. O'Malley, United States Air Force four-star general.

OLYPHANT

Olyphant is often referred to as the "Queen Borough of the Mid-Valley." Due to its location near the Lackawanna River, it provided an ideal location for its first settlers, the Native Americans. An island divided the river in two parts, and a bridge connected Olyphant and Blakely Township.

In the early 1840s, only three houses stood in Olyphant, and they were owned by the Ferris, Travis and Barbor families. But long before that, in 1798, Olyphant's first settler, James Ferris, staked his claim in the area that would later become Delaware Street.

Olyphant became a borough in 1877, and it received its name from George Talbot Olyphant (noted president of the Delaware and Hudson Railroad company in 1858) to honor the extension of the Gravity Railroad to include the borough. The extension aided tremendously in its growth and prosperity.

Mining was the chief industry in Olyphant, but smaller industries also existed, such as the manufacturing of bricks, a bottle works, a large cigar factory, a silk mill and, most notably, the Peck Lumber Company. The business district (though small) had the look of a big city. The first store was

operated by Jones and Company. The next merchant drawn to the borough was David M. Voyle, who opened his store in 1858 on Lackawanna Street; he was followed by James Jordan. John McKay built the Mahon House in 1861, Olyphant's first hotel.

Just 15 men from Olyphant fought in the Spanish-American War, but 402 saw action during World War I (with 9 lives lost). During World War II, under the Selective Service Law, the borough sent several selectees with the first contingent of soldiers, who entered Fort Meade for basic training in January 1942. Local Board Number Four, with its headquarters in Olyphant, was the first to organize in the Mid-Valley area. About 1,600 of Olyphant's bravest men served in World War II, and 47 did not return home to their loved ones.

JESSUP

The borough of Jessup was incorporated in 1876 and was named in honor of Judge William Jessup. The judge owned seven hundred acres of the borough's coal lands and was president of the Lackawanna Railroad.

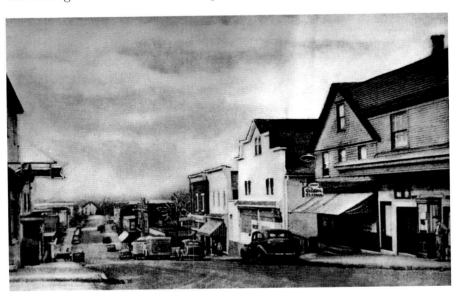

Above: Church Street in Jessup.

Opposite: Olyphant's Borough Building, circa 1912.

Mining in the area began around the mid-1850s and continued as Jessup's main industry until 1924.

Andrew Nichol sunk the first mineshaft, but unfortunately, it was not successful. The railroad helped the borough out of this bleak period; the route that ran from Jessup to Dunmore was a highly patronized means of travel from Carbondale to Scranton.

The Pierce Coal Company was founded in 1872 by business partners George Filer and Thomas Livy. The Filer breaker was built in 1872, and the first shipment of coal went out the following year. At its height, it employed five hundred boys and men.

A horrific accident happened on December 18, 1923, when the mines of the Mount Jessup Coal Company No. 1 shaft caved in, burying five men alive: Michael Neville, Michael Selszock, Joseph Kohut, Frank Shezoriah and Evan Jones, who was hailed a hero because he went back to warn the other four men of the cave in.

Another tragedy occurred in September 1939. The deaths of three young men in a dog-hole mine shocked the residents of Jessup. The accident took place a quarter mile from Moosic Lake Road near Marshwood. The mine belonged to the DeLoma Coal Company and had been idle for more than a year. However, the "bootleg" mine was being run by a local man who was stealing and selling the coal illegally.

Many Italian immigrants from Gubbio, Province of Perugia, and Gualdo Tadino found employment in the area's coal mines during the 1890s. Those who came from Gubbio, Italy, brought with them the tradition of the annual Festival of St. Ubaldo. The celebration is held on the same day in both Jessup and Gubbio every year. In May 2004, Gubbio became Jessup's "Sister City"—a lengthy process that took twenty-six years to complete. The 100th anniversary of St. Ubaldo Day was celebrated in 2009.

DALTON

Dalton was originally called "Bailey Hollow," named after George Bailey, the patriarch of the first pioneer family to move to the area. Due to its accessible location, it quickly became a popular trading place.

The name changed from Bailey Hollow to Dalton during the 1860s. Some historians credit Dr. J.C. Miles for the name change. Abel Gardner

A view of downtown Dalton, once known as "Bailey Hollow."

was one of Dalton's first merchants; he also built the borough's gristmill. The first postmaster was H.L. Holstead. The landmark "Dalton House" was erected by Lymon Dixon in the 1840s. The earliest school in Dalton was known as the Red School. Among its early teachers were Myron Hall, Wendall McClay and William Hall.

Agriculture and lumbering were the chief and only employment until the building of the Leggett's Gap Railroad in about 1850. At first, the owners of the railroad were not sure if the route would run through Bailey Hollow, but Colonel George W. Scranton made the decision to include the Dalton route. For some time, there was no railroad station in Dalton, but after the post office was built in 1854, the railroad authorities began making plans to build one and the village began to take shape.

At one time, the International Correspondence School farm and dairy was located in Dalton. The area surrounding Lily Lake was once owned by M.B. Fuller, president of the International Salt Company, and was used as a picnicking spot; it was also the location of Fuller's palatial estate. C.S. Woolworth, vice-president of the F.W. Woolworth Company, also had his summer home on Lily Lake. James Sweeney, a Scranton contractor, had a showplace near the country club, with an outdoor swimming pool, bridle paths and jumps for horseback riding.

The Dalton Memorial Community was gifted to the borough from the Dalton Men's Club. It was formed in 1925, with Dr. John Evans serving as its first president.

Dalton was incorporated as a borough on February 4, 1895; its first burgess was James P. Dickson.

THROOP

The village of Throop was made a borough in 1894, thanks to the beginning efforts of its namesake, Dr. Benjamin H. Throop. Some speculate that the first anthracite coal mine in the county was cut below the Anderson Farm, located in the borough by William Wurts, in 1814. It is also where the first settlers made their home, at the junction of Underwood and Marshwood Roads.

Out of the Old Blakely Township was carved the Mid-Valley area and surrounding communities. Throop was originally a village of Dickson City. The earliest settlement in what would later become Throop was called "Rough and Ready."

Blakely Township was named in honor of Captain Johnathon Blakely, hero of the War of 1812. Blakely was commander of the American ship *Wasp*. The anchor at Blakely Corners was placed there in his memory.

The Throop Memorial Fountain once stood at Nay Aug Park in Scranton; in the center of the ornate fountain was a boy holding a boot from which water poured forth. The fountain was dedicated to Dr. Benjamin H. Throop, but it has since been removed from the park.

At one time, there stood an old brick building on the corner of Dunmore and Sanderson in Throop. It was built in 1901, and at that time, it was the oldest surviving building in the borough until it was struck by a streetcar that jumped the tracks as it rounded the curve to come down Dunmore Hill. The building was noted for the large mural of the Pancoast Mine painted on the back bar by Throop's burgess, Fred Fabretti.

One of the worst mining disasters in the history of the northeastern anthracite coal fields occurred on the morning of April 7, 1911. A fire that started in the engine room of a main gangway of the Pancoast Mine led to the suffocation of seventy-two miners and one rescue worker. A relief fund donated by the people of the valley in the sum of $70,000 helped the families of the men who perished in the fire.

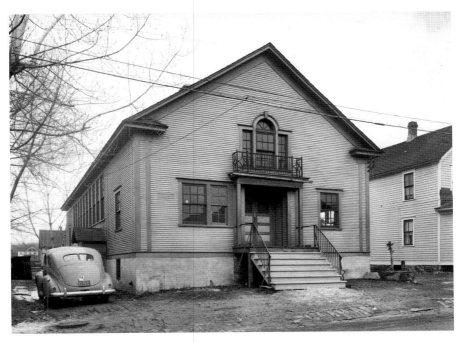

The Throop Dress Company was an institution in the borough for many years.

CLARKS SUMMIT AND CLARKS GREEN

The twin boroughs of Clarks Summit and Clarks Green owe their names to Deacon William Clark, an early settler who cleared acres called the "Green" to the point of a "summit" just north of the Lackawanna River from Scranton. Another early family was the Deacons, who settled in the area in about 1799 when it was a township. The first store was opened by Samuel Griffen in Clarks Green, and S.A. Northup was the first postmaster.

In May 1850, what was known as the "Irish War" broke out near Clarks Summit. Hostilities erupted between the Irish and German laborers who helped in the building of Leggett's Gap Railroad. Rival camps sprang up overnight, and on May 28, a battle ensued, leading to the death of one man and the wounding of numerous others.

During the early days, the twin boroughs were small country towns, but once the railroad was built, people from Scranton sought out land to build homes in the "Green" and the "Summit." The construction of highways brought more people to the area, and Clarks Summit soon became the

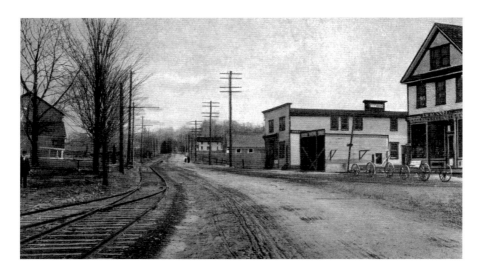

Northern Electric Railroad in Clarks Summit. The landmark Bunnell's Hardware can be seen in foreground (right). *Author's collection.*

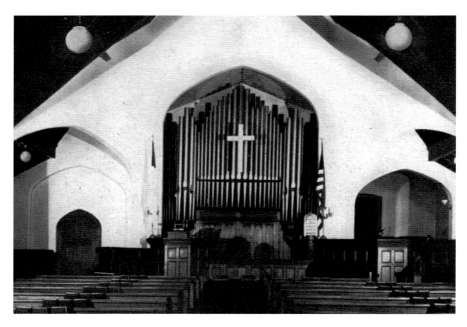

Interior view of the First Presbyterian Church, also known as the "Church on the Hill."

business district of the Abingtons. A borough charter was applied for, and it was granted on August 30, 1911.

You cannot tell the history of Clarks Summit without mentioning one of its landmarks, Bunnell Hardware Store. The family owned and operated business opened in 1911 and was the oldest store in the Summit until it was closed in 2013.

CHINCHILLA

Chinchilla was originally called "Leach's Flats" after Ephraim Leach, who made it his home around the turn of the nineteenth century. Some eighty years later, the name was changed by the first female postmaster because she had a fondness for the furry rodent; others claim that it was the wife of the postmaster, Mrs. George Tanner. The debate continues to this day.

During World War I, the name was changed yet again (but only briefly) to Pershing, in honor of the heroic general. By the end of the war, the community situated between and the Abingtons was again called Chinchilla, and it was never changed again.

A panoramic view of Chinchilla, named for the furry rodent.

MOSCOW

Moscow owes its humble beginnings to one man, the Lutheran minister Reverend Peter Ruppert. In 1830, the reverend built a log house on the land he owned in the village. Early settlers were said to be of Russian descent, which is why the village was named after their old capital. Ruppert erected a sawmill and ran a tavern for the townspeople out of his home. In 1850, he sold his land parcels to the Lackawanna Iron and Coal Company.

Lumbering and agriculture became the main industries, and the small village grew up around them. Moscow's central location in Covington Township made it a prime spot for a gristmill. Nearby townships at the time had to rely on the mills at Slocum Hollow or Pittston. Originally, Levi Depew put up the first mill. Joseph Potter rebuilt it, enlarged it and then sold it to E. Ehrgood, who built a new mill in 1873 and operated it for many years.

A post office was established in 1852 by Leander L. Griffen. Dr. C.J. Wilbur served as the first druggist and physician. Lymon Dixon built the Valley House in 1873, and B.F. Summerhill opened his premier dry goods store in 1877.

A stage line between Scranton and Stroudsburg over the turnpike was started in 1846. Joseph Loveland built on land between the Moscow House and Pelton's Dry Goods, but unfortunately the Loveland Store burned down in 1870.

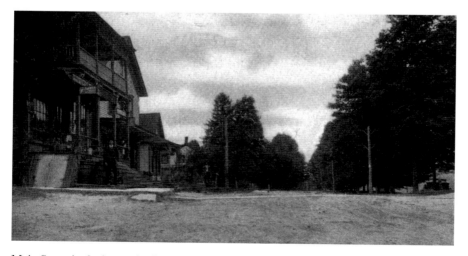

Main Street in the borough of Moscow. *Author's collection.*

Moscow had several fraternal societies, including a lodge of Masons, instituted on April 12, 1872; Odd Fellows, instituted on March 30, 1870; Red Men; Sons of Veterans; Patriotic Order Sons of America; and Junior Order.

Moscow sought a borough charter in 1908; W.B. Miller was elected first burgess. The town at the time had a population of 1,200.

GOULDSBORO

In 1856, Jay Gould, railroad magnate and financier, and Colonel Zadoc Pratt purchased a large tract of land in what was then Luzerne County along the Lehigh River and built a tannery. The settlement took the name Gouldsboro on May 12, 1871, at which time it was made a borough.

Gouldsboro, in 1859, was the scene of a battle for possession of the tannery following the split in the partnership of Gould and New York leather merchants who had bought out the Pratt interests. The tannery was reported to be one of the most extensive establishments of its kind in the United States. Gould was manager, and he lived at the settlement, which became one of the busiest along the Lehigh River. Many of the tannery hands were of Irish descent, a tough lot who frequently clashed with the Yankee woodman.

The tannery was closed in 1861; Gould was prompted to give up the tannery business for the larger field of railroad development. A second tannery, known as the Woodlawn, was opened in 1867 by H.D. Snyder. It contained a store, a wagon shop and a blacksmith shop. An acid factory was established by George Blakslee in 1866, but it was destroyed by fire two years later.

The Honorable James McAsy, one of Gould's first workers at the tannery, turned to the hotel business after its closing. His hotel was called the Gouldsboro House. Early Catholics would have to travel to Dunmore for Mass or attend services at McAsy's hotel when priests visited the village about once a month.

At the time of its height of prosperity, Gouldsboro had a population of more than 350.

DICKSON CITY

Prior to the Revolutionary War, no one lived in the area today known as Dickson City. In 1876, Revolutionary War veteran Timothy Stevens and his family settled into the meadow near present-day Main Street. In the late 1790s, Captain Vaughan and his sons began clearing the land, and soon other settlers arrived. Elisha S. Potter came from White Hall, New York, in 1797, and the following year, Luke and Michael Decker built a cabin on the site of the Parochial Residence of St. Thomas Church.

In 1814, a Mr. Stevens built a sawmill, which soon led to Dickson City's first industry. For the first fifty years, the early pioneers lived off the land and helped develop the borough with practically their bare hands.

Messieurs Pughe, Baker and Jones leased the coal lands at Dickson and sold their lease to William H. Richmond and Charles Wurts. This exchange became the genesis of Dickson as a village and led to the Elk Hill Coal and Iron Company. The post office added "City" to the name to distinguish it from other towns of the same name in Pennsylvania. The breaker of the Elk Hill Coal and Iron Company was destroyed by fire in 1883.

The village, originally named "Priceburg" in honor of Eli Price, progressed rapidly after John Jermyn sank the Johnson Shaft in the 1880s, and coal became the main source of income.

St. Thomas Catholic Church, Dickson City. *Author's collection.*

In April 1875, Dickson City was incorporated as a borough, named after Thomas Dickson. The Dickson-Blakely Traction Street Railway Company was chartered in 1892. It connected Dickson City, Scranton, Blakely and Archbald, and this brought more people and development to the borough.

OLD FORGE

Dr. William Hooker Smith came to Wilkes-Barre in 1772. The surgeon, who served in the Revolutionary War, was said to possess a keen, scientific mind. He was among the very first to realize the great value of the vast mineral deposits throughout the valley. For that very reason, he began to purchase coal land in Pittston, Exeter, Providence and Wilkes-Barre. Many regarded Smith as a visionary, but very little attention was paid to his operations.

In 1789, he and James Sutton built a forge for the purpose of converting ore into iron. It stood miles above the mouth of the Lackawanna River, and many referred to it as the "Old Forge," for which the borough would later be named. The Smith-Sutton forge was the first of its kind in the valley.

Jesse G. Fell, an associate of Smith's, was quoted as saying:

> From 1812 to 1815 my father rented and occupied the hotel, farm, and sawmill on the north side of the river. At the time the forge was in full operation. It was situated below the road bridge on the south bank of the river, so that the ore and coal were unloaded from the road into the forge. The water power for running the forge was taken from the river by a race dug through the rock just above the bridge. The forge was cheap building, and the ore was picked up on top of the ground over the hills and valleys and hauled in carts by oxen. Charcoal was burned on the mountains for the forge. The business was owned by three of the most enterprising and prominent men of the day, Doctor William Hooker Smith, and his two sons-in-law, James Sutton and N. Hurlbut. The forge stopped operations in 1816 or 1817.

Dr. Smith was one of the original justices of Luzerne County; his commission was signed by Benjamin Franklin. Eventually, he relocated to Tunkhannock, where he passed away in 1815 at the age of ninety-one. Another early settler was Dr. Joseph Sprague, who came from Hartford and plotted the land between Pittston and Slocum Hollow. He and his family

made their home on Main Street until he and his neighbors were driven away by the "Pennamites" during the "Pennamite war."

In 1808, the Charles Drake family from New York came to the lower end of the borough. Upon their arrival, they opened a general store, built a tannery and kept a place of entertainment for horse and man. Drake purchased large tracts of coal land that he later sold off to various coal mining operations.

Edmund B. Babb built an iron foundry in 1820 and made farm utensils. The Babb family was succeeded by William Howard, who in turn was followed by brothers George M. and Steven H. Miller. By 1870, Old Forge had four schools, employing one teacher at each, and 180 students in attendance. During this time, the borough was unsurpassed in its geographical beauty. Semi-colonial mansions owned by the Drakes, Stewarts and Smiths lined the thoroughfare. The highway was flanked on each side by fragrant locust and maple trees. The farms were well maintained, and pastures were filled with cattle and fields with corn, wheat and rye. Churches, Sunday school and various aid societies satisfied the residents' spiritual needs, and they found entertainment in skating, sleighing and the annual barn dance.

The first coal operation began after the Civil War. The Chittenden Breaker was located along the Delaware, Lackawanna and Western Railroad, not far from Moosic Road. Within a matter of decades, two shafts were sunk, and company houses and a large company store were built. Other mines were opened by the Jermyn Coal Company and the Pennsylvania Coal Company.

By the end of the nineteenth century, the population had doubled in size. Company houses were now being purchased by their occupants; farms were plotted into lots, sold and occupied. Old Forge became a township in 1871 and a borough in 1899. The first election was held on May 13, 1899, and Andrew Kennedy was elected burgess.

MINOOKA

Minooka has been known by various names—Needham's Patch, Davis' Patch, Coary Hollow—all of which were names of coal mine operators in the area. According to a deed from the Susquehanna and Wyoming Valley Coal Company dated 1867, Minooka was referred to as the village of Glen Newman, township of Lackawanna and the county of Luzerne. But there is still uncertainty as to the meaning of the name "Minooka." One

legend claims that there was an English captain named Carr who owned and operated a mine in Carr's Patch. Supposedly he had a daughter (in some accounts a niece) who made friends with an Indian maiden named Minooka, and she convinced her father to name the land in her honor. The name is a collaboration of two Indian words, *Mino* (good) and *Aki* (earth).

The first known settler of Minooka was George Fassold Sr. His son, George Jr., built the second house in the area on Corey Street. The first building erected there was said to be a meeting place for local peddlers. Existing records did not name the builder, but the first owner was identified as Joseph Nulkie of Taylor. The uniqueness of the building is the fact that not one single nail was used in its construction—only wooden pegs. A tavern stood on land owned by Jeremiah McCarthy, the proprietor was named James Whitley and it was appropriately called "Whitley's Red Tavern." A schoolhouse was constructed in 1854 on church property, and it was also used as a place of worship.

As with most communities in the early beginnings, coal mining was Minooka's chief industry. Many of the mines were owned by individual people, such as Needham, Coary, Davis and Carr. In later years, Glen Alden and the Hudson Coal Company took over the operations.

In the early part of the twentieth century, Scranton came down with a case of baseball fever. There were a number of different teams in the area, the "Minooka Blues" among them. The O'Neil boys (Steve, Jack and Mike), Mike McNally and Chick Shorten all went on to play in the major leagues.

Percentage-wise, the young men of Minooka led the country in the numbers of those who joined the military during World War I. Most returned to their families and loved one when the war ended, but thirteen of those young men sacrificed their lives fighting for our freedom. Among them were John Connelly, James Connelly, Joseph Devers, John Heffron, John Fitzhenry, John Walsh, James Timoney, William Murphy, Michael Flynn, Michael Lacy and Miles and Paul Sinkevicz.

The early history of Minooka is very similar to other mining towns in northeastern Pennsylvania, but the spirit of the community, which exists to this very day, makes Minooka stand out among the rest.

TAYLOR

Cornelius Atherton, born in 1736, was the grandson of Colonel Humphrey Atherton from whom all the Atherton families in America descend. Prior to

Cornelius coming to Lackawanna Valley, he lived in Dutchess County, New York, where he worked as a blacksmith. Cornelius learned the trade at a young age, discovering how to convert iron into steel when he was barely old enough to shave. For some time, he was in business with many prominent New York merchants and made quite a name for himself. His next move was to Cambridge near Boston when he was offered the title of superintendent of an armory owned by Samuel Adams, brother of President John Adams. While working there, he made guns for the Revolutionary War. When word leaked out, the armory was burned to the ground due to the fact that it was supplying citizens with guns, and the British commander of Boston feared that it would cause discord between the colonists and the mother country.

Once again, Cornelius relocated, this time to Plymouth, Pennsylvania, where he was able to work and prosper at his trade. He owned a large trading canoe, which he kept stocked with articles he made with his own hands. Both he and his sons would run the canoe to Northumberland in order to sell his wares to the locals.

Jabez Atherton, Cornelius's eldest son, was born in 1761 and was only seventeen years old when he fought in the Battle of Wyoming. It was actually Cornelius who had been drafted, but Jabez objected and immediately volunteered to become his father's substitute. As the brave young man marched into conflict, he passed his parents' dwelling, and the entire family came out to see the troops off. Tears flowed freely; all who witnessed the sight were deeply moved. It would be the last time the Athertons saw their oldest son. Sadly, Jabez fell during the battle. His name tops the list on the Wyoming monument. The young man's body is surmised to be among those who were brutally slaughtered near Queen Esther's Rock.

When the news of his son's death reached Cornelius, the entire family grieved and quickly prepared to leave the area for fear of imminent danger. His wife was sickly and confined to bed, but her fear was stronger than her ailing health, and she joined her family in their hasty departure. Soon the Athertons and other families headed toward the river with a few of their most valuable possessions in tow. When they reached Nanticoke by canoe, John Atherton, Cornelius's second-oldest son, then took to horseback and proceeded by land on the west side of the river. After he made a path, he returned for the others, and their trek continued. Mrs. Atherton, being unable to walk, was put on the back of an old mare, using their bedding as a saddle. The group had not gone but a mile before another woman collapsed. She was also put on the old mare's back. No sooner was it done but the poor old horse sank to the ground from exhaustion. These unfortunates wandered about in New Jersey, afflicted

and destitute. They suffered the loss of many things but mourned most for the dead they had to leave behind and could not give a decent burial.

Cornelius and his family stayed in New Jersey for two years before returning to Lackawanna Valley. In 1782, he purchased five hundred acres of land and proclaimed it "Ye Settlement of Lackawanna." Cornelius built his home in the area known today as Taylor. His sons John and Eleaser are considered the borough's founding fathers. Cornelius's first wife died soon after they reached New Jersey. He remarried in 1786 and fathered seven children with his second wife; in total, he had fourteen children.

All those who knew Cornelius Atherton called him a pious man; he possessed a strong religious character. After he settled in Taylor, his faith grew even stronger. Ministers of the gospel during that time were few and far between. Possibly once every three months, a traveling preacher would come along and give a sermon in someone's private home or barn, thereby following the Savior's command, "as you go, preach." Feeling that it was his religious duty, Cornelius began calling the people together on the Sabbath and read to them sermons from books. He would stand with his hands and face upturned to heaven and invoke blessings on his family and friends. He kept the prayer meetings going for years.

It is believed that Cornelius remained in Taylor for two decades, after which he moved to Chenango County, New York, where he died in 1809.

DUNMORE

The old Connecticut Cobb Road ran through the town and traced the route of present-day Drinker Street. In 1783, William Allsworth, a Connecticut shoemaker, settled in the "corners." Here is where he decided to make a clearing through the forested area, build a log cabin and open an inn. Allsworth Inn became a point of interest for many weary travelers on their way to Wyoming. Deer ran about in abundance, and venison was a featured item on the menu; this is what prompted the early settlers to nickname the area "Bucktown."

For twelve years, Allsworth did not have any neighbors until the summer of 1795, when Charles Dolph, John Carey and John West cleared the nearby land to make room for their homes. These settlers were soon joined by Edward Lunnon, Isaac Dolph, James Brown, Philip Swartz and Levi DePuy between the years of 1799 and 1805. The somber hamlet of Dunmore had begun to grow.

Many historically prominent people are laid to rest at the Dunmore Cemetery, such as members of the Scranton family and Dr. Matthew Shields.

In 1813, Dr. Orlo Hamlin and his wife settled near Allsworth Inn; he is noted for being the first physician and surgeon in Providence Township, which Dunmore was still a part of at this time. Soon the population doubled in size. Stephen Tripp built a sawmill and gristmill in 1820; that same year, the first store was opened at the corners. The establishment of the Pennsylvania Coal Company in 1847 put Dunmore on the industrial map. By the early 1860s, residents had begun a campaign for the creation of a borough. This was authorized on April 10, 1862; Calvin Spencer became Dunmore's first burgess.

THE ABINGTONS

Abington Township was created by the Court of Luzerne County in 1806. It was part of the old Tunkhannock Township, which included Scott, Clarks Green, Clarks Summit, Glenburn, Dalton, West Abington, La Plume, Waverly, North Abington and Benton Greenfield, as well as part of Blakely and Carbondale.

The scattered settlements remained an unbroken wilderness until 1820. The early settlers named the township Ebingtton after Colonel Ebbings, who sold

Tintype photo of farmland in the Abingtons.

them the land under the Connecticut claims. These land titles were challenged by Pennsylvania law and declared worthless. They were so angry with Colonel Ebbings's deception that they changed the name to Abington after a town in Wyndham County, Connecticut. When the post office moved to the home of Dr. Bedford, the name changed again, this time to Abington Center.

The building of the Philadelphia and Great Bend Turnpike brought more people into the area. The turnpike was chartered by the Pennsylvania legislature in 1818; work began in 1818 and was completed two years later.

John Flanagan, from Plymouth, Pennsylvania, built the first house in Abington Center, shortly after the completion of the turnpike, which was referred to at the time as the "street leading into the woods."

George Parker came to the Abingtons from Rhode Island by way of Carbondale. He wanted to build an inn that brought pleasure to the public. The kitchen was equipped with bake ovens at the side and an iron bar across the front for hanging kettles. A bar occupied a large part of the main floor. As the stagecoach came down the pike, George could be seen waving with a sign in hand that read, "Refreshments for Man and Horse."

The first school in Abington was taught by Elder Miller in 1804 in his log cabin. The class consisted of seven boys and one girl. The first one-room schoolhouse was built in 1830 on Waverly's Main Street. It was a borough school until 1869.

Under the laws of the commonwealth, the town was chartered as a borough. Some historians give the date as 1853 and others 1854. The name Abington could not be used for the new borough because there was already a town by that name in Pennsylvania. The name Waverly was chosen from Sir Walter Scott's novel of the same name.

JERMYN

Jermyn is surrounded by the boroughs of Archbald and Mayfield; it was incorporated as the borough of Gibsonburg on January 28, 1870. It gained the name in 1869 when William Gibson bought up most of the land in the area. Prior to that, it was called Baconville. In 1874, the borough changed names once again, this time in honor of John Jermyn, the coal baron who brought with him prosperity and jobs.

Mr. Jermyn established extensive collieries as well as successful mine operations throughout the borough. He also established the Jermyn Steam Flouring Mills in 1870. Jermyn's first hotel was built in 1866 by Louis Pizer; that same year, John Nicholson opened the Farmer's Hotel. Among the merchants of the borough were the Baker and Winter brothers, general stores; James Allen, clothing merchant; and Miller Pryor and Richard

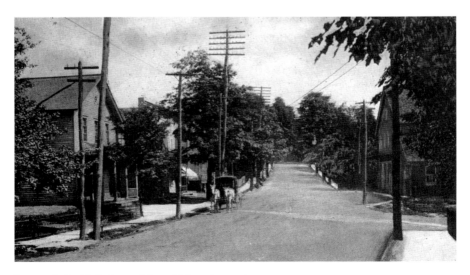

Jermyn is the birthplace of first aid for mineworkers.

Hawkins, butchers. The post office was established in 1869 and operated by John Gardner.

Jermyn is the birthplace of first aid for mineworkers. In 1899, Dr. Matthew Shields organized the lifesaving program. On May 29, 1943, the residents of Jermyn honored Dr. Shields by dedicating a plaque in his honor on the property adjoining the borough building.

THE NAME GAME

How did the towns and boroughs in the county get their names? Read on.

- Archbald: Named in 1846 after James Archbald, Carbondale's first mayor. Prior to that, it was called "White Oak Run."
- Blakely: Named for Captain Blakely, a commander of the United States during the War of 1812.
- Jermyn: Once known as "Baconville," it received its name from coal baron and entrepreneur John Jermyn.
- Keyser Valley: Named after Timothy Keyes, one of the first white settlers in Lackawanna Valley.
- Lackawanna: From the Indian name *Lee-haw-hanna*, meaning "the stream that forks."
- Monsey: Monsey Avenue takes its name from the Indian tribe Minsi or Monsey.
- Moosic: Named for the great herd of moose that inhabited the area at one time.
- Nay Aug: From the Indian name *Nau-Yaug*, meaning "noisy or roaring brook."
- Scranton: Named in honor of the Scranton family, who settled there in the 1800s.
- Taylor: At one time called "Taylorville" after businessman and financier Moses Taylor. Later, the post office shortened it to Taylor.
- Waverly: Named after Sir Walter Scott's novel *Waverly* in 1805.

Part II

PEOPLE OF THE COMMUNITY

A TRIPP BACK IN TIME

Ira Tripp was born on January 6, 1814; his family were notable pioneers in the Lackawanna Valley. Ira was a man from the eighteenth century more than the nineteenth. Unlike so many men of his time, he was not an industrialist, and he was not interested in accumulating wealth. However, it was difficult for him to avoid, for under the land he owned were some of the richest anthracite deposits in the area.

Ira received the title of "Colonel Tripp" upon being appointed aide-de-camp to the governor. He served in the Union army during the Civil War and was taken prisoner. He was forced to endure a winter in Libby prison.

Tripp was often described as a jovial man with a heart of gold; no man in Lackawanna Valley had more friends than the colonel. He was known from one end of the valley to the other as "Uncle Ira." Later in life, his trademark became his long white beard and the unusual manner in which he smoked Havana cigars. The colonel was forbidden to smoke due to health reasons, so his valet/coachman, George Keyes, would puff on the cigar and direct the smoke in Ira's direction for his enjoyment. Back in those days, people were not yet aware of the dangers of secondhand smoke.

In 1838, Colonel Tripp married the love of his life, Rosanna; she was an astute businesswoman in her own right. After her beloved Ira passed away

in 1891, Rosanna spent her winters in California and the rest of the year at the Tripp House.

Sadly, Ira and Rosanna's children all predeceased them. Isaac, the oldest, died at the age of forty-three. Their middle child, Leander, married and had children of his own but left the earth too soon, when he was just thirty. The youngest child, Gertrude, never recovered from injuries she sustained from falling off her horse; she passed on at twenty-six years old. Better known as "Gertie," the young lady had captured the hearts of many. Her funeral was one of the largest the valley had ever seen.

Mrs. Tripp died in 1899, and the Tripp House was sold in the early 1900s to new owners not related to Lackawanna Valley's pioneer family.

ROBERT H. MCKUNE

The fourth mayor of Scranton, Robert Hayworth McKune, was born in Newburg, New York, on August 19, 1823. His father died when he was just a boy of three. By the time Robert turned twenty-one, he had worked as a shoe clerk, run a bakery owned by his mother and opened a grocery store in his hometown.

After his discharge from the army, in which he served during the Mexican-American War, Robert traveled out west to California. He was one of the old "forty-niners" and became the first American to open a bakery in Panama. He stayed only seven months in the California gold fields before returning to New York. In 1862, he arrived in Scranton and entered into the insurance business. Robert was identified with almost every public enterprise during his residence here. In 1875, he was elected mayor, and it was during his term that the Great Riots of 1877 occurred—he showed much bravery in his attempt to quell an angry mob of thousands on Lackawanna Avenue.

Robert H. McKune has been described as the most genial of men, with an unbounded enthusiasm in all of his endeavors. He was a born fireman and was never so much at home as when he was with firefighters. "The Boys" all honored and loved him.

For many years, McKune suffered from a neuralgic affliction of the heart. He had several attacks; his physicians declared that he would not rally from them, yet he proved them wrong each time. Sadly, in October 1894, while visiting his sister, Robert H. McKune passed away. When the news of his death reached Scranton, it was met with much sorrow.

Reverend Samuel Logan, pastor of the First Presbyterian Church, eulogized his friend with these words:

> *Robert H. McKune belonged to a generation which had passed away, a generation which had been honored and which would be honored in generations to come. He was what was known as a forty-niner. Robert was one of the good men and now this good man has passed away, let us reverence his name and endeavor to learn a valuable lesson from his life.*

MASTER DIVER FROM THROOP

In the early hours of April 4, 1933, the U.S. Navy airship *Akron* went down into the turbulent waters of the Atlantic Ocean off the New Jersey Coast during a thunderstorm. The loss of life was great due to the lack of life jackets; seventy-three of the seventy-six men perished either by drowning or from hypothermia. Among the dead was Rear Admiral William Moffett, chief of the navy's Bureau of Aeronautics and leading proponent of the U.S. Navy rigid airship program. Afterward, *Akron*'s sister ship, the USS *Macon*, and others received life jackets to prevent future tragedies such as this.

In May of the same year, Throop native Edward Obelkevich was among the first four crew members of the USS *Falcon* who went to the bottom of the Atlantic to salvage parts of the *Akron*'s wreckage. After the dirigible's control house was located, the divers, led by Obelkevich, carried out the task of raising it and other parts of the wreckage to the surface. Hydrogen, oxygen and gasoline tanks were used to cut the twenty-ton vessel in pieces in order to lift them, claimed Obelkevich.

His mother, who lived on Charles Street in Throop, was quoted as saying, "Edward was an adventuresome boy, he always longed for a career in the Navy."

Obelkevich, who at the time had been in the service for fifteen years, had much experience with working under water. He had been the first diver to take part in the rescue work of the S-Z4 submarine that sank off the coast of New London. For that mission, he was under the water for more than two hours before being relieved by another crew member.

Salvage parts of the *Akron*'s wreckage were put on display at the Mid-Valley Radio Store, located at 307 George Street in Throop. Hundreds of curious spectators were seen in front of the store shortly after the window display was completed.

A big "Welcome Home" ceremony was held on May 11, 1933, and included a parade and a program of speeches in honor of the navy master diver. After the ceremonies, Mr. Obelkevich pitched the first baseball in the game between the Throop Boosters and the Old Forge PAC.

THE COUNTY LOSES A GOOD FRIEND

On January 8, 1892, the headline in the *Tribune* read, "Lewis Pughe Dead: The Attack of the Grippe Proved More than His Aged System Could Handle, He Was 72 Years Old."

Lewis Pughe was born in North Wales in 1820. As a young boy, he worked as a tailor's apprentice in order to learn the trade that his parents chose for him. At twenty-two, he came to America and found employment in New York. In 1849, he married Miss Mary Mason, and the couple moved to Carbondale, where he started in the merchant tailor business. The following year, he was elected the first treasurer of the Pioneer City. He also served as alderman for five years and as school director for nine.

More than a decade later, Mr. Pughe and Colonel William N. Monies became partners and opened a cracker baking business in Scranton. M and P Bakery was located on the corner of the 500 block of Lackawanna and North Washington Avenues. During the riot of 1877, many people sought shelter in the bakery as bullets riddled the exterior wall of the structure.

As a member of the Constitutional Convention in 1873, Lewis won his greatest distinction in public service. He was a strong advocate for the formation of a new county and fought very hard for one independent of Luzerne's Government. It took five years, but Lackawanna became the sixty-seventh and last county formed in Pennsylvania.

In 1876, Mr. Pughe was chosen as a presidential elector Pennsylvania for Rutherford B. Hayes. Pughe also had an interest in local politics. He was also appointed as director of the poor in 1877. Under his direction, the name of the Providence Poor Farm was changed to the Hillside Home. Protestant and Catholic services were made available every Sunday at the institution, and many improvements were made to the building thanks to this man's efforts. With the death of Lewis Pughe, the city lost an entrepreneur and respected citizen, as well as a good friend.

A Pennsylvania Historical Marker was unveiled on August 3, 2008, at the intersection of Lackawanna and North Washington Avenues at the location

where the riot took place in 1877. The marker is entitled "Coal Miners and Laborers Strike of 1877."

A WOMAN DOING A MAN'S JOB

Louise Tanner Brown was no ordinary lady; a native of Beaver, Pennsylvania, Louise was on her way to college when her father, a Methodist minister, suddenly died. For six years, she ran a beauty parlor and then came to Scranton, where she met and married George W. Brown. They were only together a few short years when George (or G.W., as he liked to be called) passed on in 1923. Louise now had to face the dilemma of selling the popular draying business or running it herself. She chose the latter. Draying means to haul goods by way of a low sideless cart, and G.W.'s business was located at Lackawanna Avenue and Cliff Street.

When she took over for G.W., the business was operating with four motor trucks, two teams and eleven people in her employ. Some seven years later in 1930, fourteen motor trucks ran the streets of Scranton, and the number of her employees had doubled. Indeed, the Draying Company flourished under Louise's direction, but not without its share of difficulties. When she was faced with a lack of capital to purchase the first truck, Mrs. Brown had to state her case rather convincingly to the manager of the trucking company in order to establish credit. Then there was the perplexing problem of labor, as some of the white male truck drivers were adamant about working for an African American woman. But eventually, harmony was achieved by the establishment of union scale wages and the division of employees equally between black and white. This practice eliminated race antagonism.

In her personal life, Mrs. Brown was a lover of poetry, and ironically enough, in Scranton she was known more for her excellence as a public speaker than as a business executive. For many years, she entertained a host of people throughout Pennsylvania with her poetry readings. Louise moved from Scranton to Ohio three months prior to her death in 1955.

A highly respected lady of many talents, Louise Tanner Brown's epitaph should read, "To succeed in a woman's line of business is an achievement that comes to many businesswomen. But to succeed in a man's line of business is an honor extraordinaire."

PROMINENT WOMEN OF SCRANTON

There was a book written in 1906 by author Dwight J. Stoddard titled *Prominent Men: Scranton and Vicinity.* The book gives the reader the opportunity to read brief biographies of more than one thousand men who left their mark in local history—men such as George W. Scranton, co-founder of the Scranton Iron Furnaces; George Sanderson, developer of Green Ridge; Colonel Ira Tripp, founder of the Scranton Trust Company; and E.B. Sturgis, who introduced the electric streetcar in 1886.

But men were not the only ones to leave their marks. Many of their female counterparts contributed to local history as well. Mrs. Harriet G. Hollister Watres, famed author and poet of her day, wrote under the pseudonym "Stella of Lackawanna." Her book *Cobwebs* is available at local libraries.

Jennie Lewis Evans, who was born in Wales, came to America with her parents and settled in Scranton in 1868. During a time when it was unheard of, Jennie formed a business partnership with David Reilly in 1888, and together they operated Lewis & Reilly, a successful shoe store located on Wyoming Avenue for many years.

Mary C. Owen Nivison, MD, was born in 1834 in Enfield, New York; she came to Scranton in 1871and became the first female physician in the city. Her office was located at 310 Lackawanna Avenue, and she had a very extensive practice.

Mina Robinson, after her husband's death, continued to run the popular Robinson's Brewery on the south side of Scranton. She was also the co-founder of the South Side Bank.

Mrs. James A. Linen was one of the founders of the American Red Cross and the local farmers' market.

Mrs. Everett Warren, Mrs. William W. Scranton, Mrs. Henry Kingsbury, Mrs. C.S. Weston and Mrs. J. Benjamin Dimmick were all founders of the Century Club, which is more than one hundred years old and still in operation.

H. Evelyn Brooks's career began as a schoolteacher in both the Carbondale and Scranton School Districts. She was later elected the first Lackawanna County superintendent of schools and served in this position from 1879 to 1884. Miss Brooks was known for being very capable and conscientious but criticized men very sharply.

Harriet Clay Penman was society editor for the *Republican* newspaper and helped organize the Visiting Nurse Association.

Ellen Fulton was a music teacher and prominent organist. She gave recitals at the chamber of commerce and helped organize community concerts.

Marion Langan Munley, wife of Robert W. Munley, served in the statehouse from 1947 to 1966 and became secretary of the House.

Some of their names you may have recognized and some not, but their contributions to the growth of this county cannot be denied.

THE NEXT CHRISTY MATHEWSON?

Back in 1902, many baseball critics believed that the southpaw pitcher David O. Williams was in the same league as Factoryville native and local sports legend Christy Mathewson. Actually, the two men were teammates for a time in the 1898 Honesdale Club, and some credit Williams for teaching Mathewson the "Fadeaway," described as one of the freaks of pitching art.

David Owen Williams was born on February 7, 1881, in Scranton. Thomas and MaryAnne Williams had immigrated to the States from Wales several years before his birth. David was educated in the public school system and then went on to graduate from Bloomsburg State Normal School. He furthered his education at State College. It was around this time that he began getting some work as a professional ballplayer. In 1899, he played for Springville, a New York team; his outstanding performance resulted in him getting signed with Buffalo and then later a Pennsylvania team called the Lestershires, where he is recorded to have had fifteen strikeouts in one game.

According to the April 5, 1902 issue of *Sporting Life*, he was signed to the Boston Americans, but the club didn't debut him until that July. After pitching his first game, he was released and sent home, only to be called back two weeks later. Many were not impressed with the southpaw pitcher, including the fans, who felt that he had a lot to learn about pitching and that he should have been in a primary league. Despite the harsh criticism, Williams returned to the pitcher's mound on August 3, but due to his poor performance, he was replaced by a pinch hitter in the top of the ninth. By September, Williams had been permanently released form the Boston Americans.

Following the end of his baseball career, Williams moved to Duluth, where he mined ore and, in 1915, joined the state militia, Company M of the Third Minnesota. In 1918, Williams contracted pneumonia at Camp Cody in New Mexico and passed away in April of the same year in Hot Springs, Arkansas. David O. Williams was laid to rest at the Dunmore Cemetery.

AUTHOR/PLAYWRIGHT CALLED SCRANTON HOME

Jean Kerr, best known for her book *Don't Eat the Daisies*, was born Jean Collins in Scranton on July 10, 1923. Jean attended Marywood College, which is where she acquired her passion for the theater. According to her classmates, the aspiring writer was much loved and had a wonderful sense of humor.

It was during Marywood's production of *Romeo and Juliet* that Jean met the man with whom she was destined to spend the rest of her life. Walter Kerr was a professor of drama at Catholic University. The two were married soon after Jean earned her bachelor's degree from Marywood. She went on to continue her studies at Catholic University of America in Washington, D.C., and received her master's degree in 1945.

A year later, the Kerrs made their debut on Broadway with *Song of Bernadette*, a play adapted from the Franz Werfel novel about a Frenchwoman who was canonized after having visions of the Virgin Mary. The play was not a success, and neither was *Jenny Kissed Me*, written two years later by Jean in her attempt to start a solo career. The couple teamed up again in 1949 with *Touch and Go*, and this time the pair had a hit on their hands. Offers began pouring in. Jean joined forces with Eleanor Brooke to write the play *King of Hearts*, starring Donald Cooke, Jackie Cooper and Cloris Leachman. The '50s comedy, based on the life of a comic strip artist, was well received, but Jean's first notable success outside the theater came in 1957 with her book *Don't Eat the Daisies*. First the novel became a bestseller, and then, in 1960, it hit the big screen in an adaptation starring David Niven and Doris Day. It was picked up by NBC as a TV sitcom and ran from 1965 to 1967. Kerr was also the author of *The Snake Has all the Lines*, *Penny Candy* and *How I Got to Be Perfect*, a collection of humorous essays published in 1978.

Jean did not return to Scranton very often, but during a visit in 1970, she told the *Scranton Times* entertainment editor, Sid Benjamin, that she regretted the fact that the highly erotic film *Midnight Cowboy* won the Oscar for Best Picture that year. "I'm tired of their orgies," she said. "If they want to have orgies, let them have them on their own time. You shouldn't come out of the theatre wanting to commit suicide in the lobby."

Jean Kerr passed away from pneumonia at the age of eighty.

DAYS OF GLORY

Many are probably familiar with the movie *Glory*, starring Matthew Broderick and Denzel Washington. The epic film tells the story of the famed Fifty-fourth Massachusetts United States Colored Troops and the battles it fought during the Civil War.

At dusk on July 18, 1863, Colonel Robert Gould Shaw gathered six hundred of his men on a narrow strip of sand just outside Fort Wagner on the South Carolina coast and prepared them for the fight. "I want you to prove yourselves," he said, "the eyes of thousands will look on what you do tonight."

As darkness of night closed in around them, Shaw led his troop over the fort's walls and right into a bloody massacre. The Union generals had miscalculated the number of Confederates waiting for them on the other side, and the Fifty-fourth was outnumbered by 1,100 soldiers; 281 of Shaw's men were killed, wounded or captured. Captain Shaw himself was shot in the chest and died instantly. It was yet another sad day in the history of the Civil War.

David E. Thompson was among the soldiers of the Fifty-fourth to survive the battle and the rest of the war. He is buried in Dunmore, Pennsylvania, at Forest Hill Cemetery. How did David get from the sandy, bloodstained shore of South Carolina to our coal region? No one really knows. According to Thompson's military records, he was discharged from service in Charleston, South Carolina, in August 1865. After that, records show that he came to Scranton and lived at 205 Raymond Alley with his wife, Martha, and their three sons: Neal, John and Charles. His mother-in-law, Eliza McGrue, also lived with the family.

In November 1882, tragedy struck the Thompson family. David's wife, Martha, died at the very young age of twenty-seven; she is also buried in Forest Hill in the paupers section. A short nine months later, tragedy struck once again when his six-year-old son died of dropsy.

Corporal David Thompson passed away several years later on May 2, 1890, while walking down Lackawanna Avenue. He suddenly fell to the ground and died instantly of an apparent heart attack. David was only fifty years old, and two days later, he was buried in the section of Forest Hill Cemetery reserved for the veterans of the Civil War.

THE WASHBURN FAMILY

Calvin Washburn was another early settler of the valley. He purchased a farm that ran from Main Avenue to Keyser Valley, and for many years, it

was hailed one of the finest in the area. Washburn was also the owner of a beautiful brick residence on the site of the First Baptist Church.

When West Scranton began to develop, Calvin and his son, Nicholas, began to sell parts of the farm for building lots. The sale of the land made the family wealthy, and they gave much back to the ever-growing community. It was Calvin who donated the lot at the corner of Washburn Street and Hyde Park Avenue to the congregation of the Washburn Presbyterian Church; an edifice was erected in 1914.

When Calvin decided to sell his own property on Washburn Street for building purposes, it is said that the land was sold with the understanding that liquor could never be served along the blocks from Main to Rebecca Avenues. The promise was kept for many years.

Nicholas Washburn was one of the oldest residents of the city at the time of his death on April 1, 1887. For many years, he owned and operated a lumberyard on Scranton Street. In his later years, he was engaged as a weigh-master for the Delaware, Lackawanna and Western Company.

The Washburn homestead, once located at the corner of Main Avenue and Washburn Street, was considered a landmark until it was razed in 1914 in order to make way for the Hyde Park Lodge No. 339 Free and Accepted Masons. The selling of that property was the last of many acres the Washburn family had owned at one time; it was the end of an era.

HENRY T. KOEHLER

Henry T. Koehler's first job was as a newsboy, press feeder and office boy for the *Scranton Times*. His political career began at the age of twenty-six, at which time he was elected to county auditor in 1887. Four years later, he was elected register of wills by a margin of one vote—talk about your close elections. After serving just one term, he was then named deputy register of wills and first assistant clerk of Orphans Court, where he remained until his retirement. Koehler was a well-known courthouse figure throughout his many years of service to the community. He was also one of the leaders who supervised the erection of the Washington monument at the Courthouse Square. In 1950, at the age of eighty-nine, Henry passed away after being ill for quite some time.

The Koehler name is very prominent in Lackawanna County. One Pennsylvania historical marker honors the founder of the former Scranton

School for Deaf, Reverend Jacob M. Koehler, Henry's brother. The reverend established the original institute in 1882.

THE HISTORIANS

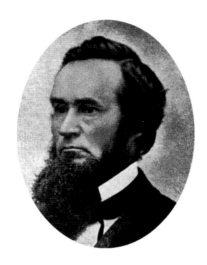

Portrait of doctor, author and historian Horace Hollister.

The city of Scranton will celebrate its 150th anniversary in 2016, and Lackawanna County will turn 140 just two years later in 2018. During that time, many authors have written books on both subjects. Reverend Samuel C. Logan told us about the 1877 riots in *A City's Danger and Defense*, and Dr. Benjamin Throop gave us *A Half Century in Scranton*. Others, like Dwight J. Stoddard, wrote about the *Prominent Men* of Scranton and surrounding vicinities. The following three historians, as well as historians past and present, should be commended for their passion to preserve history for the generations.

Horace Hollister, MD, settled in Providence and practiced medicine there for nearly thirty-five years. Hollister's second love was literature. He penned several books, the most notable being his *History of the Lackawanna Valley*. His other works include *History of the Delaware Canal Company*, *Recollections of Our Physicians* and *Coal Notes*. The good doctor also had another love: collecting Native American relics. It is said that his collection was one of best in the country.

Colonel Frederick L. Hitchcock was born in Waterbury, Connecticut, on April 18, 1837. During his residency in the Green Ridge section of Scranton, Hitchcock wore many hats—that of lawyer, vice-president of the Scranton Building and Savings Union, second vice-president of the Scranton Board of Trade, colonel of the Twenty-fifth Regiment USCT in the Civil War, lieutenant colonel of the Thirteenth Regiment, NGP (1877–88), city treasurer in 1906 and, finally, author. He wrote the *History of Scranton*, volumes 1 and 2; the works are excellent sources of information about the city and its people.

Thomas F. Murphy was chief associate editor of the *Scranton Times*. He gave more than sixty years of service to the newspaper and was an outstanding authority on local history, so much so that in 1928 he authored two volumes on the subject entitled *History of Lackawanna County*.

GEORGE W. BACKUS

There was no better known man in Scranton than George W. Backus. For many years, he owned and operated a hotel and a billiard and pool hall in the city. He had the distinction of being the first person granted a license to run a restaurant on Washington Avenue, where the Fern Café stood for many years.

Backus came to Scranton from Montrose when he was a young man. His first job was that of a desk clerk in the old Wyoming House. Having saved a little money Backus quit the position to open a restaurant and billiard parlor of his own. He would go on to open the hotel on Washington Avenue. This granted him the title of prominent hotelman in the city. Later in life, a reversal of fortune took a toll on his health.

In May 1919, Backus was taken ill and needed to be hospitalized for a time. He recovered and went back to business as usual. On the Saturday after his release from the hospital, he complained of not feeling well but left his house despite this fact. He was walking down Adams Avenue, near the Hotel Holland, when he experienced a weak spell and sat down on the hotel's steps. He immediately fell over onto the porch; the clerk and guests in the lobby promptly went to his aid. A doctor was called, but by the time he arrived, George W. Backus, prominent hotelman, had succumbed to a heart attack. Ironically, he passed while sitting on the steps of one of his competitors.

SCRANTON'S FIRST BAND

Henry G. Diller was the leader of a band in Germany when he was only eighteen years old and a player in the Dodsworth Band of New York, a famous musical organization known around the country. By the time Henry reached Scranton, he was a well-polished musician.

As the story goes, Mr. Diller took a trip to Honesdale one day in 1864 to visit his friend Ferdinand Burger. They were seated in a room one evening engaged in a conversation when Mr. Diller suddenly exclaimed, "Why don't you get the police to stop that noise in your backyard; it sounds like a convention of cats howling on the fence."

To which Mr. Burger answered, "The noise you are referring to is coming from a new band having a practice session next door."

"Ach," responded Mr. Diller. So into the yard he went. After introducing himself, he took the members into a room and tested each of their musical instruments and then asked each one to play him the scale. An idea came to him, and he felt that Scranton would offer a better audience. Out of the thirty men he auditioned that day, he chose only six, and then he added another six members when he returned to Scranton, including himself, making a band of twelve. According to Diller's philosophy, "Twelve was enough for any band; they only have twenty and thirty in a band to make noise."

Mr. Diller became the leader of Scranton's first band, and in those days, it was necessary for the leader to write the music or steal it from another musical group. Not only was the band known locally, but it was also popular throughout the entire Northeast. It was in demand as far as Binghamton. Diller's Silver Coronets String Orchestra rates were six dollars per day and expenses for each player, with Mr. Diller getting a larger amount.

As with any band, problems sometimes arise. The end of Diller's came after they played an engagement in Pittsburgh. There had been an argument between certain members upon their return to Scranton, and in a rage, Mr. Diller smashed several horns. No one ever learned the real reason for the band's demise. Mr. Diller explained it as being a chain of circumstances that led up to its end—among them Diller's busy schedule. Being the proprietor of the Eagle Hotel did not always allow him the time to travel around the country with the rest of the band.

THE MAN OF STEEL

Carl W. McKinney literally climbed the ladder of success from office boy to a high position in a big industrial corporation. This rag-to-riches story began in Kutzville, Pennsylvania, where Carl was born. His family relocated to Scranton when he was four years old. His formal education lasted only a

short time before he became an errand boy for W.W. Scranton, the general manager of the Lackawanna Iron and Coal Company.

In 1881, W.W. Scranton severed ties with the company and built a plant of his own called the Scranton Steel Company. W.W. had always been impressed by McKinney's job ethics and loyalty, and so he offered him the position of general manager of the new mill; McKinney readily accepted.

During the prime of his life, Carl was a powerful man, both mentally and physically, but he chose to rule by his strong will rather than by physical force. Ironically, for a man of his intimidating size, he had a soft, meek voice, yet the authoritative tone made up for what it lacked in volume, earning his workers' respect. McKinney was always ready to pat his workers on the back for a job well done.

Before retiring, McKinney was general manager for a time at the Sparrow Point plant of the Maryland Steel Company. In April 1910, he went to New York to be operated on for appendicitis. He recuperated well from the surgery and was released from the hospital within a week's time. McKinney caught a cold just days after returning to the city, and it caused an abscess in his ear that, in turn, brought about the earthly end of Scranton's "Man of Steel."

They Made Their Mark

Michael E. Comerford, founder and president of the Comerford Theatres Inc., was known as the motion picture pioneer of Pennsylvania and shared this honor with only three others in the United States. Comerford lived most of his young life in Plymouth, Pennsylvania. His career, like so many, began in the coal mines, but later he engaged in commercial pursuits. When motion pictures made it to the big screen, Mr. Comerford was the first in Pennsylvania to make it available in a small, improvised theater in downtown Scranton. From these humble beginnings, it grew into the Great Comerford Chain of Independent Theatres in the United States.

Priscilla Longshore Garrett was an artist who studied at the Drexal Institute, School of Design for Women and the Pennsylvania Academy of Fine Arts. Her works included portraits, landscapes, figure configuration and still life. She was the painter of such works as *Three Old Trees*, *Kitchen Composition* and *Adams Street*, all of which received awards and medals. In

1940, she presented a one-woman exhibition at the Everhart Museum. Her studio was located in East Mountain.

ELIZABETH TAYLOR (not that Elizabeth Taylor) became the director of the Everhart Museum of Natural History, Science and Art in 1933. She also served as president of the Lackawanna County Art Alliance from 1939 to 1942. Her artistic creativity included portraits, decorative and monumental sculptures and paintings. Her studio was also located in East Mountain.

ROY STAUFFER was the owner of the Roy Stauffer Chevrolet Agency located on Washington Avenue in Scranton. But Mr. Stauffer did a lot more for the community than just sell them cars. He served as the director of the Pittson Hospital, the Pennsylvania Automotive Association, the YMCA and the Scranton Chamber of Commerce. He also served as president of the Glenwood Mausoleum and was a member of the Rotary Club and the Scranton Club.

EDWARD S. JONES was the president and founder of the Mid-Valley Hospital in Blakely, Pennsylvania. He was well known for being a world traveler and a philanthropist and for being one of the prime movers in the building of the County Road, one of the most beneficial improvements in Lackawanna Valley.

BYRON S. HOLLINSHEAD was president of the Scranton-Keystone Junior College. He was the author of many educational articles that were published in journals, magazine and newspapers. Hollinshead also held educational positions with Bucknell University, Camp Cedar Hill for Boys and the General and the Education Board of New York and served as editorial advisor for Houghton, Mifflin Company.

THE WINTON FAMILY

The Winton name has long been connected with the development of Scranton. William Wilander Winton, a native of Otsego County, New York, relocated to Scranton after completing his studies in Latin and legal branches.

W.W. found employment in the general store owned by his father-in-law, Harry Heermans; while working there, he began to study law. Although he was never admitted to the bar, W.W. had extensive knowledge on the subject and was made executor of his father-in-law's estate.

Following Harry Heermans's death, W.W. partnered with A.B. Dunning and opened a store in Providence. For a time, he lived in New York, where he received business training. The metropolis made him realize the opportunities yet to be discovered in Providence, and he soon returned.

W.W. was the organizer and president of the Winton Coal Company, whose mines were located in Winton, a town named in the family's honor. He also played a major role in the organization of the Second National Bank of Scranton and the First National Bank of Providence.

After a long and successful career, W.W. Winton passed away on December 30, 1849.

The Peck Family

Johnathon Wilson Peck, the son of Samuel and Sarah, was a small boy when his family settled in an area that later would become Peckville. At a suitable age, J.W. and his father became engaged in the lumber business. Both men were very much involved with the development of Peckville, so much so that the borough was named in Samuel's honor.

Fenwick Peck, Johnathon's eldest son, became his father's assistant in the family's lumber business. At the age of twenty-two, he became a partner and remained in this

Portrait of Jonathon Wilson Peck, lumber magnate. *Author's collection.*

position until 1886. With the help of prominent businessmen, including his father, he organized the Lackawanna Lumber Company.

Fenwick was invested in other industrial fields; he served as vice-president of the Peck Lumber Company and was director of the Scranton Textile Company and the Scranton Mills. The Electric City was Fenwick's hometown. He resided at 545 Jefferson Avenue for many years.

BLUME'S CARRIAGES AND WAGONS

One could say that C.W. Blume was brought up in the wagon making business. Father William and son manufactured the finest wagons and carriages for a quarter of a century. The enterprise began in 1891 and was located on Dix Street in Scranton, but it served the entire county.

The factory was equipped with a twenty-horsepower steam engine and thirty-five skilled employees. William Blume and Son produced a variety of light and heavy carriages and wagons, and many were made to order. Repairing any vehicle that ran on wheels was a specialty of this family-owned business. The local company had a wonderful reputation throughout Lackawanna County and beyond.

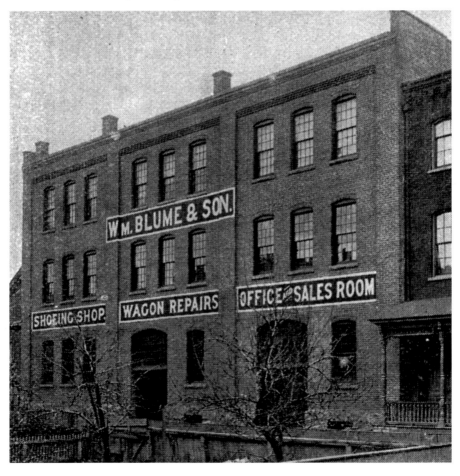

Blume's advertisement for its prestigious carriages and wagons. *Author's collection.*

COMFORT KALLUM SHERMAN

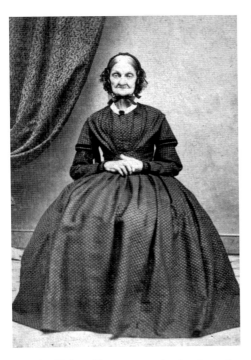

Comfort Kallum Sherman was the daughter of a Revolutionary soldier. *Author's collection.*

Comfort Kallum Sherman, born in 1794, was the daughter of Luther and Amy Kallum and the second wife of Johnathon C. Sherman. The 1850 census lists the couple as living with their children in Jessup.

Luther Kallum, Comfort's father, was from Connecticut and fought during the Revolutionary War (1775–83). Connecticut provided food and supplies to the Continental army for the duration of the war and became known as the Provision State.

Johnathon Childs Sherman was born on October 30, 1783, in Portsmouth, Rhode Island. He was married to his first wife, Cornell, in 1810, and the couple had two children before she passed away in 1822. After this, he married Comfort, and they had six children.

Johnathon died in 1856, and Comfort joined him in 1872. The two are buried in a private family cemetery in Susquehanna County.

THE BOYS ON THE WALL

Quinto P. Rossi was a technician fifth grade, Eighteenth Cavalry Reconnaissance Squadron, during World War II. He was taken prisoner by the Germans on Christmas Eve 1944 during the Battle of the Bulge. The *Scranton Times* reported that the twenty-four-year-old son of Mr. and Mrs. Paul Rossi was previously listed as missing in action in Belgium since December 17.

As history tells us, the fortitude and courage of the American soldier was tested against great adversity during this battle. Nobody knew this better

Quinto P. Rossi, POW in World War II. *Author's collection.*

than Mr. Rossi. He lived it. For quite some time, he remained a prisoner of the Germans, and the torture he suffered went beyond words.

Quinto and many of his boyhood friends went off to battle; Scranton's south side contributed a large draft quota on a regular basis throughout the war. These young men grew up in the same neighborhood and went to school together, and many of their friendships continued after the war. But some were not so lucky.

Understandably, Quinto seldom liked to talk about that time of his life, but sometimes,

Boys on the wall. *Left to right*: Chick Keeler, Valen Pagliari, Quinto Rossi and Chester Bartoli. *Author's collection.*

on Christmas Eve, the ghastly memories would resurface. Like those of the "Death March" he was forced to endure; besides the physical pain, the German soldiers inflicted mental anguish. When one of Quinto's friends fell to the ground, he reached to help him up, and as he did so, the German soldier shouted that he would shoot him on the spot if he so much as touched him. He felt the barrel of his gun on the back of his head, and Quinto didn't doubt that the German soldier would go through with the threat.

Miraculously, Quinto survived with a heart that was somewhat weaker and horrific memories that would haunt him for the rest of his life. He received an honorable discharge on September 27, 1945, as well as many decorations and citations, including two Bronze Medals.

Quinto P. Rossi passed away on April 15, 2012, at the age of ninety; it was very hard for his family to say their final goodbyes to a real American hero—their American hero.

The following quote was originally written for World War II soldiers, but today it has grown to represent all soldiers:

> *And when he gets to heaven,*
> *To Saint Peter will he tell:*
> *One more soldier reporting, Sir,*
> *I've served my time in Hell.*

ALWAYS BUSY

They were always busy at the Lewis & Reilly Shoe Store. In fact, its slogan, "Always Busy," is still visible on the Wyoming Avenue building in downtown Scranton. To this day, many people do not realize that half of Lewis & Reilly was a woman—an amazing businesswoman at that.

Jennie Lewis was born in South Wales; her parents brought her to Scranton in 1868. Jennie's father, Rees, was a coal miner; he also had a good head for business. While in Wales, he discovered a rich vein of ore, which he shrewdly kept hidden. He then asked to be transferred to venture mining, and after an appropriate amount of time passed, he pretended to discover the find and received $1,500, much more money than he would have received earlier. The large sum paid the Lewis's family way to America.

Jennie was fortunate; she obtained a very good public school education. As a young girl, she worked as a clerk for Goldsmith Brothers. Her ambitious

nature made Jennie strive to become a merchant and open a store of her own. Most people balked at the idea of a woman running anything other than her own household. But not David M. Reilly; despite her gender, he knew a good business partner when he saw one.

The two opened the store in 1888. The business grew and prospered as a result of well-directed efforts and the best modern methods. Jennie never asked any favors of her male counterparts, and it didn't take long for her to become known as "Scranton's Leading Business Woman"—a title she so rightfully earned and deserved.

In 1909, Jennie married Elias E. Evans, and they had three children. But raising a family did not slow Jennie down. She remained very active in the community; she served for twelve years as a member of the board of directors of the YWCA, she taught a puritan Bible class at the church and she also served as a member of the Scranton Chamber of Commerce.

Throughout her life, Jennie remained a staunch advocate of women in business. She believed that there was a place for women in every field and endeavor, and she was always glad to extend a helping hand to young women just starting out in their careers.

In December 1938, Lewis & Reilly celebrated its golden anniversary. Jennie passed away shortly afterward at the age of seventy-eight. Jennie Lewis Evans will always be an inspiration to women not just in Scranton, but everywhere.

Time to Make the Chocolate

Gertrude Jones, daughter of Gomer and Ellen, was born at the turn of the century in 1903. Her father died suddenly at a very young age, and her mother suffered from a heart condition, leaving Gertrude financially responsible for the family. At the age of twelve, Gertrude went to work at the candy store in the Scranton Dry Goods Department Store; where she learned the art of "candy dipping."

Seven years later, Gertrude married Elmer G. Hawk. Not long after, they had their first child, Elmer R., followed by Richard in 1928. For several years, Gertrude stayed home to raise her sons, but when the Depression hit, Gertrude went back out in the workforce. At the time, good chocolate dippers were scarce, and she found employment in many different shops over the years. Then, in 1936, feeling that she could earn as much money

making candy on her own as she could working for someone else, as well as having the added plus of staying home with her sons, Gertrude began making chocolate out of the kitchen of her Bunker Hill home.

Twelve-year-old Elmer Jr. shared his mother's love for candy dipping and helped her by packing the candy into boxes. Their small family business soon flourished. Gertrude worked out of her home until 1962. Soon they moved the candy business to its location at the top of East Drinker Street in Dunmore. The move was necessary because their Mark Avenue home, along with the others in the Bunker Hill section, was bought by the Pennsylvania Department of Transportation for the construction of a massive bridge for Interstate 81.

In those first official years of business in their new Dunmore location, the family purchased machines to help relieve some of the time-consuming manual labor. Gertrude also made the decision to establish a fundraising foundation, contracting with local religious and civic groups that raised funds by selling Gertrude Hawk Chocolates. This turned out to be a very wise business decision.

In the 1970s, Gertude passed the torch to her son Elmer Jr., and two decades later, he, in turn, passed the torch to his son, David Hawk. Today, seventy-five Gertrude Hawk Chocolate Shops can be found throughout Pennsylvania, New Jersey and New York. One could definitely say that Gertrude came a long way from her little kitchen in Bunker Hill.

SCRANTON'S PIONEER PRINTER

Fred Wagner was born on Christmas Eve 1838 in Bavaria, Germany. At six years of age, he and his parents came to America and settled in Wilkes-Barre. There, he entered into the printing business as a young man still wet behind the ears. For many years, he worked his way up the proverbial ladder and was made foreman of the *Luzerne County Waechter*, a newspaper published by Robert Bauer.

In 1864, Fred married Miss Elizabeth Hausman, and a year later, the couple moved to Scranton. He immediately started the publication of the *Wohenblatt*. The office of the German newspaper was located on the 300 block of Penn Avenue. Later, it would move to Spruce Street. Wagner is known for being the first person to build a permanent building on that certain city block.

Once the newspaper business started to increase, Wagner moved once again, this time to Lackawanna Avenue, where it remained until it was taken over by his son, Frederick. Frederick later decided to move the *Wohenblatt* back to its original site on Spruce Street.

In 1881, the first and only year that directors for the poor board were elected, Mr. Wagner, a staunch Democrat, was put into office. However, shortly afterward, the Supreme Court decided that the election of directors was unconstitutional, and Wagner was immediately thrown out of office. That would be his only experience with politics, but his influence would not be lost on the German residents of the city. Through his efforts, the Lackawanna County section of the German-American Alliance was organized. He held numerous offices in the organization and at the time of his death was its honorary president.

Wagner was also a member of Roaring Brook Conclave of Heptosophs and a lifelong member Schillerlodge, Free and Accepted Masons.

Fred's health had been on the decline for many months. A few days before his death, his family was given a glimmer of hope by the doctors because his condition had begun to improve. Unfortunately, it was not to be. Fred Wagner, one of Scranton's pioneer printers, passed away at 8:30 a.m. on January 29, 1913.

SHOPLAND HALL

Alfred Shopland was the representative of his family in Lackawanna County. In 1854, Alfred's father, Samuel, brought the entire family to Scranton from their homeland of England. Alfred was only eleven years old at the time, and he attended the local public schools. At the beginning of his business career, he opened a drugstore in Hyde Park, but soon a better financial opportunity presented itself and he became interested in the Willow-Ware business on Lackawanna Avenue.

In 1874, he moved to New Jersey, where he again operated a drugstore for nine years, but he never forgot Scranton. In about 1880, Alfred returned to the city and went looking for work. But what he found instead was a wife. The marriage of Alfred Shopland and Miss Eugenie M. Moore of Waymart took place in 1883. The couple were active members of the Second Presbyterian Church, and Alfred was a member of Peter

Williamson Lodge Lackawanna Chapter, Royal Arch Masons, and Irem Temple, Mystic Shrine in Wilkes-Barre.

Alfred was stricken with paralysis due to a stroke at the couple's summer home in the Thousand Islands, and on September 23, 1915, he passed away.

Shopland Hall in the Scranton Cultural Center at the Masonic Temple was named in memory of Alfred by his wife, Eugenie.

Part III
EVENTS TO REMEMBER

THE LARGEST POTHOLE IN ARCHBALD

In 1884, Archbald's famous pothole was discovered by a miner employed by Jones, Simpson & Company. The phenomenon is called a glacier pothole. According to a report made by Professor J.P. Lesley, state geologist, to Edward Jones of the aforementioned company:

> *The surface ice of a glacier melts under the hot sun, flows over the surface of the ice, and plunges into crevasses to the bed of the valley down which the glacier is moving. These waterfalls make deep potholes wherever they keep rocks twirling, round depressions of the valley bed. When a pothole is finished by a change in the location of the waterfall, it gets filled with smaller rounded boulders and sands.*
>
> *If there were any horizontal coal beds not far underneath the bed of an Alpine Valley such a coal bed would be sure to have one or more glacial potholes in it.*

During the ice age, it is believed that northern Pennsylvania was entirely covered in a solid sheet of ice three thousand feet thick and that many potholes formed varying in depth from ten to eighty feet, most of which were concealed by drifts of gravel, sand and clay once the ice melted.

Archbald's Famous Pothole, circa 1899.

Many of these potholes were later discovered by accident, like the one in Archbald. According to additional reports by geologists, the ice marks on the rocks in the region show that the glacier rose high above all our hills and mountains and that its course was generally down the Lackawanna Valley.

The miner who discovered the pothole was Patrick Mahon, a resident of Archbald. Upon his landmark discovery, he was driving a heading in the drift mine of Jones, Simpson & Company. Another miner fired a blast, and when the stone and water came rushing out through the hole, the miners nearby let out a cry of alarm and ran for safety, fearing that the mountain was about to fall on them. Edward Jones of Blakely, the manager of the mining company, was summoned. Upon his inspection, he gave instructions to have the area examined by a professional in the field, and geologists were called in.

Colonel Hackley, the landowner, gave the sum of $500 to build a retaining wall around the glacial wonder. During the dedication ceremonies of the Archbald glacier pothole, which is still today a big

tourist attraction, state geologist Professor J.C. Benner addressed the crowd with these words:

> *During Napoleon's Campaign in Egypt, as he sat on his horse under the shadow of the pyramids, he said, "My Men, forty centuries look down upon us." {Professor Benner pointed toward the pothole and concluded with} My friends, today millions of years look upon us.*

THE SPIRIT OF THE AMERICAN DOUGHBOY

The doughboys were the American soldiers sent to France during World War I, but the origin of the term is unclear to this very day, although there are many theories. Some suggest that the term came from the soldiers' method of cooking their rations. Meals often consisted of dough and rice baked in the ashes of a campfire or molded around a bayonet and cooked over its flame. Then there's the button theory, noting that U.S. infantrymen wore coats with brass buttons that resemble the doughboy dumplings eaten by the soldiers and sailors of earlier days. During World War I, the slang term came to belong exclusively to the 4.7 million Americans who served their country, but by World War II, doughboys had become alternatively known as "Yanks" or "GIs."

Scranton has its very own doughboy; he is located off Moosic Street, near the Harrison Avenue Bridge. The inscription on the monument plaque reads, "Colonel Frank J. Duffy Memorial Park Dedicated May 30th, 1940."

Lieutenant Colonel Frank Duffy was an engineer and the highest-ranking local resident killed during the Great War. Duffy was struck down by a mortar shell on August 17, 1918, while stepping from a motorcycle sidecar after making a tour of the lines. He and his cycle driver, Private First Class Frank G. Fiore, were killed instantly.

The land for Duffy's Park was set aside in 1934 due to the Depression; it would take another six years to raise the money for the monument. The sculptor, E.M. Viquesnay, created the *Doughboy* in 1920 in response to a national interest for those who died, were wounded or served in World War I. Woodrow Wilson's secretary of war, Newton Baker, encouraged communities nationwide to erect memorials in honor of the doughboys. Viquesnay wanted to depict the "spirit" of the doughboys' determination

to preserve freedom for the country, and this is why he chose to portray him striding forward in an erect posture through no-man's-land.

Scranton's *Doughboy* has seen his fair share of vandalism since 1940. The rifle and bayonet were repaired in 1957 and again in 1968 following extensive damage suffered at the hands of insensitive and unpatriotic vandals while trying to tear the statue from its base. Upon recent inspection, the bayonet and rifle sling are missing, and there are many cracks visible in the statue.

The island-shaped grounds that surround the monument are very well kept, thanks to the efforts of a nearby neighborhood family who for three generations have cut the grass and planted flowers in the doughboys' honor.

HORACE HOLLISTER, MD, VERSUS STEUBEN JENKINS, ESQ.

Dr. Horace Hollister dabbled in more than just medicine during his lifetime. Besides his practice, he was an author and an avid collector of American Indian relics. His collection was said to contain some ten thousand pieces used in peace and war times—including rare pipes, rings, amulets, battle axes, war clubs, large and small pestles, spears and more. Steuben Jenkins, a lawyer from Wyoming, Pennsylvania, also boasted that he owned an extensive collection of relics reflecting the American Indians' early manners, customs and arts, particularly their stone implements of husbandry, the chase and war. He had been collecting items for more than thirty years from all parts of the United States. Hollister claimed to have more than ten thousand pieces, making his collection the largest in the world, but Jenkins accused the doctor of letting his imagination run away with him. The rivalry ensued.

Jenkins made Hollister an offer. He was willing to display his collection alongside the doctor's in any hall in Scranton and allow the public be the judge as to whose was bigger; the winner would then become the owner of both collections.

Dr. Hollister's reply was swift: "Mr. Jenkins' collection is said to be magnified by those who have peeped into all his boxes and drawers, but mine is arranged in a pill shop where anyone can view it because it is too valuable to be hid away for 30 years in obscure places like Mr. Jenkins'." Hollister agreed to the offer but under his own conditions. Instead of the winner gaining the loser's collection, he felt it better that the winner received

a certificate or diploma and the runner-up make a fifty-dollar donation to the Home of the Friendless."

"If I should possibly lose," said Hollister, "of which there is no danger because it is the largest in the world, I should have the pleasure of knowing the public had seen Jenkins' relics which are too large for a pill shop, but just the right size for boxes and remote sheds."

Jenkins turned down Hollister's offer; he did not believe in giving the fruits of his labor to someone who had no claim on them—like the poor unfortunate souls in the Home of the Friendless. The controversy went on for weeks during the summer of 1865; the gentlemen used the *Scranton Register* newspaper as their verbal venue.

Finally, in September, the Exhibition of American Indian Relics, owned by Dr. Hollister and Steuben Jenkins, was displayed at the annual fair on the grounds near the Wyoming Battlefield. A committee appointed by the Luzerne County Agricultural Society unanimously called the competition a draw. In the end, each gentleman was awarded a silver pitcher.

"Dog" Days of Summer

When you think of summer, you think of barbecues with hamburgers and hot dogs sizzling on the grill. When you think of the best wiener in the area, you think of the Original Coney Island Lunch.

Before World War I, Steve Karampilas left his homeland of Greece and came to America. When he first arrived, he settled in New York City, where he learned the restaurant business. He took the culinary knowledge he attained in the bustling city with him when he moved to Scranton some years later. In 1923, Karampilas opened Coney Island Lunch at 100 Cedar Avenue. Even though the menu was simple, his secret Greek chili sauce covering the hot dogs set them apart from all others in the area. Dressed in a buttoned-down shirt and tie and puffing on his signature "House of Windsor" cigar, Steve Karampilas never missed a day of work from 1923 until his death in 1972.

The family continued on with the business. Today, the Original Coney Island Lunch is owned and operated by Karampilas's grandsons, Pete and Bobby Ventura. For as many years as the restaurant resided at the Cedar Avenue location, the family never owned the building. In 1987, when it

became apparent that the landlord was not going to update the building or tend to the many needed repairs, they began looking for a new home and found it not too far away, on the 500 block of Lackawanna Avenue.

The new location still serves the same delicious traditional recipes that have delighted taste buds for generations. And we aren't the only ones who think its Texas Weiners are the best; in 2014, Scranton's Original Coney Island was voted number three for "America's Best Hot Dogs"!

SCRANTON CHALLENGES HOUDINI

Legendary magician/escape artist Harry Houdini was no stranger to the Electric City. He had performed on Scranton's stages numerous times during the vaudeville era. On one particular occasion in 1915, Mr. Houdini was called out by the Standard Brewing Company, known at the time for its Tru-Age beer. The challenge issued by the brewery entailed Houdini escaping from one of its large casks filled with its popular suds—provided the magician assumed all responsibility for bodily injury.

Houdini accepted the brewery's challenge, with the condition that the seal of the cask not be airtight; this would allow him to have oxygen should it take longer to escape than anticipated. The event was set to take place at the Poli Theatre on February 26, 1915, and many of the city's residents turned out.

When the curtain opened, several of the brewery's employees began to fill the cask with the Tru-Age beer. Once full, Houdini stepped inside, and the same workers sealed him shut. Minutes ticked by as the audience watched with bated breath, silently wondering if the enigmatic magician had performed his last challenge or if he would live to escape another day. Houdini did not disappoint; he emerged triumphantly from the cask to the sound of thunderous applause.

The Standard Brewing Company was formed in 1904 by Otto J. Robinson and Patrick Cusick. It was located on Penn Avenue and Walnut Street in Scranton. It was one of the most successful breweries in the city and the last one standing until it ceased operations in 1914.

A BICYCLE BUILT FOR TWO

The Scranton Bicycle Club was the oldest of its kind in the city. In 1881, the same year the bicycle was introduced to the public, several residents of Scranton organized a club exclusive to cyclists. Some of the original members included E.B. Sturges, George Sanderson, J.B. Fish, J.W. Pentecost, A.J. Kolb, W.B. Rockwell and L.M. Horton. Members of the club met in a small building on Spruce Street, directly behind the Forest House; today, it is the site of the Hotel Jermyn.

In 1888, the club purchased land on the 500 block of Washington Avenue and began building its new home. The organization flourished, and its membership grew, so much so that an addition was built onto the clubhouse. By 1914, members' interest in cycling had waned, and the club devoted more of its time to sports and social activities; still, the name of the organization remained unchanged. At the time, it was the only surviving bicycle club in the country. The organization represented all that was good and pure in club life—its unconditional and uncompromising stand against the sale and consumption of alcohol and gambling had always been enforced.

Members of the Scranton Bicycle Club.

On June 28, 1892, another popular organization was formed called the Green Ridge Wheelmen. At first, only cyclists were allowed membership into the club. Its purpose was to "advocate the principles of good roads and labor for the pleasure of the welfare of its members."

I LOVE A PARADE!

In 1762, the Irish in Boston were the first to hold a St. Patrick's Day Parade in America. New York's parade began in 1848, and the grand parade in Scranton also dates as far back as the early 1840s. According to the late historian Thomas Murphy, the events had been planned by local Irish ironworkers. The grand marshal was John Hawks; the parade route commenced in the Nativity section of South Scranton and ran along Cedar Avenue to Lackawanna Avenue. The first American flag carried in a procession in this city flew at the head of the marchers on that day. As the story goes, the festivities lasted well into the evening, with people dancing to the sounds of Irish music and bagpipes.

The St. Patrick's Day Parade is held annually in downtown Scranton.

Carbondale had its first St. Patrick's Day Parade in about 1833. According to a story passed down through the generations, the parade began at 7:00 a.m. and lasted until dark—some suspect that this could be an exaggeration.

After that first parade in Scranton, history becomes rather vague. There were other parades, but whether they were annual or sporadic could not be confirmed due to the lack of records. The annual Scranton St. Patrick's Day Parade celebrated today began in 1962, and several reports claim that it was the first since 1905. On Saturday, March 17, 1962, thousands of spectators dressed in a sea of emerald green adorned the streets of downtown Scranton to watch the marching bands and a slew of decorated floats. Judge T. Linus Hoban served as the parade marshal, and Edward J. Lynett, editor and publisher of the *Scranton Times*, was honorary marshal. Twelve divisions and eight bands took part, including those from the Knights of Columbus, Ancient Order of Hibernians, Catholic Young Woman's Club and the Catholic Boy Scouts of America. The revival of Scranton's St. Patrick's Day Parade was a huge success and has since become an annual event that people come from far and wide to attend.

TAKE ME OUT TO THE BALLGAME

The Scranton Baseball Club was an amateur organization made up of businessmen from the city. It can be compared to a college club; none of the players received compensation, as that was considered unbecoming of a gentleman. The club was first organized on May 6, 1865, under the name of Wyoming Baseball Club by James A. Linen, Markus D. Botsford, Henry C. Dowd, F.H. Simpson, Peter C. Carling and Charles H. Welles.

Shortly after the club was organized, it received a challenge from the Susquehanna Baseball Club of Wilkes-Barre. Of course, the men of Scranton accepted the challenge. The game was played in Wilkes-Barre on September 1, 1865, to a large crowd of spectators, both men and women. The final score was 18–6, with the Scranton boys as the victors. The win made the club very popular, and membership increased to 150. The name was then changed to the Scranton Baseball Club in 1866, and it was incorporated by an act of the Assembly the following year under the new name. At this time, the club did not have suitable grounds for practice. Eventually, it succeeded in securing land owned by the Lackawanna Iron and Coal Company between Mifflin Avenue and the Lackawanna River. It was there barely a year when the Union

Railroad, exercising its right of eminent domain, cut the ball field in half, causing the club to lose more than $500.

It then secured land owned by Colonel Ira Tripp on what was then known as the Scranton Race Course in Diamond Flats. This area on Providence Road was previously the home of the great Indian chief Capoose in the eighteenth century. By 1867, the club had played fifteen games and was victorious in all but one. The team was composed of the following players: James L. Linen, captain and pitcher; Markus D. Botsford, catcher; William M. Silkman, first base; Henry C. Dowd, second base; R.J. Matthews, third base; William T. Hickoll, shortstop; Walter Chur, left field; Charles A. Hurlbutt, center field; and H.A. Coursen, right field—with John J. Albright and John F. Snyder as substitutes. The club disbanded in about 1870 due to business pressure on its members and the arrival of professional baseball.

THE YEAR WITHOUT FIREWORKS!

When one thinks of the Fourth of July, one automatically thinks of fireworks, those bright shooting bursts of wondrous colors that light up the night sky on a warm summer evening. Back in the 1960s and 1970s, Memorial Stadium on Providence Road was always the place to be; after a day of picnicking, families would pack into their cars and head to the stadium, waiting for the light show to begin.

In 1918, the governor of Pennsylvania proclaimed "No Fireworks on the Fourth." According to an article published in the *Scranton Times*, Governor Martin G. Brumbaugh recommended that July 4 be celebrated in Pennsylvania without fireworks, like it was originally celebrated in 1777. Brumbaugh concluded, "It is wicked to waste money on senseless fireworks…and instead the old-fashioned celebration will show patriotism and religious fervor."

In 1927, an ordinance prohibiting the sale of fireworks was put into effect in the city of Scranton due to the many casualties in prior years. However, in 1937, the greatest number of accidents was reported since the ban was placed on pyrotechnics a decade earlier. Forty-six casualties occurred in Scranton alone, and fifty-six more were reported throughout Lackawanna County.

Among the fifty-six victims in Scranton was a fourteen-year-old boy who was seriously injured when a firecracker went off in his hand. His

right eye was badly cut, endangering his eyesight, and he suffered burns on his fingers.

Two years later, in 1939, a new state law was passed banning the use of fireworks, and Scranton's law officers enforced it to the hilt. Many other activities were planned to celebrate Independence Day that year. Headlining the list was a baseball game between the Scranton Red Sox and the Wilkes-Barre Barons at Athletic Park. Lakes and amusement parks throughout the state were booming with holiday visitors, and those who chose to stay in Scranton had the opportunity to attend a variety of programs in local theaters.

Part IV
LEAP OF FAITH

FIRST PRESBYTERIAN CHURCH, CARBONDALE

Numerous Scotch and English Presbyterians were among some of the first settlers to the Pioneer City. Two reverends, Joel Campbell of New York and Lyman Richardson of Susquehanna, organized the local Presbyterian church on June 27, 1829.

The congregation first met in the schoolhouse with Reverend John Noble and church elders Sylvanus Jessup and Samuel Hodgden. Ground was broken for a church in 1834, and the First Presbyterian Church of Carbondale was dedicated on February 17, 1836. This church was demolished in the 1860s to make room for a new brick structure.

FIRST METHODIST EPISCOPAL CHURCH, CARBONDALE

In 1835, there were a good number of Methodists, Presbyterians, Catholics and Baptists in the valley. The Methodists in Carbondale first met at the home of John Lee. The Carbondale Methodist Episcopal Church was organized in the fall of 1830. Some of its charter members included Mr. and Mrs. John Lee, Mr. and Mrs. Wanton Hill, Jessie and

Above: First Presbyterian Church, Carbondale, circa 1909.

Left: First Methodist Episcopal Church, Carbondale, circa 1914.

Addison Clark and H.B. Jadwin. The original church was erected in 1832. A new church was built in 1850 and dedicated in May of the same year.

ST. PATRICK'S CHURCH, OLYPHANT

Reverend P.J. O'Rourke was the first pastor at St. Patrick's in Olyphant. He is also credited for building the rectory in 1876, a year after the opening of the church. Tragedy struck on June 13, 1881. While celebrating Sunday Mass, Father O'Rourke was attacked by a mentally unstable man, who tried to shoot him. He survived the shooting but later died in 1888.

Father O'Rourke was succeeded by Reverend E.J. Melley. The new priest purchased a cemetery, reinterred the body of Father O'Rourke and began a fund for a new church. Reverend Melley was followed by Dr. P.J. Murphy in 1889. Instead of building a new church like the former priest had intended, Father Murphy had the old church enlarged and remodeled.

A parochial school was opened in 1893, with the Sisters of the Immaculate Heart in charge of educating the students. Reverend Dr. Murphy was a good friend to mine workers. He attracted the attention of Theodore Roosevelt, and the two became longtime friends.

St. Patrick's Parochial Residence in Olyphant.

ST. ANN'S MONASTERY, SCRANTON

More than one hundred years ago, the Passionists arrived in Scranton. They were loved so much by the community that the clergy was invited to stay by Bishop Hoban and start their own congregation. A ten-acre tract of land, high above the city in the "Roundwoods" section of West Scranton, was chosen for them as a site to build their church. At that time, it was a heavily wooded area and a favorite spot for picnics and evening walks to enjoy the cool mountain air. Diagrams of underlying coal mines by engineers reassured everyone involved that there was no danger of a subsidence.

On March 25, 1904, Mass was celebrated for the first time with Bishop Michael Hoban; many were in attendance, and there were high hopes for a strong new parish. Several years later, in August 1911, a tragic event shattered those hopes when a coal mine subsidence severely damaged the monastery. Again, two years later, another subsidence forced the clergy to evacuate, fearing that a major collapse would follow. On July 28, 1913, just two days after the Feast of St. Ann, a miracle took place. While the priests knelt in prayer, they became startled by a tremendous rumble followed by a deafening silence. What was assumed to be a slide turned out to be two huge boulders moving into place underneath the sacred building. Those boulders

People being blessed outdoors during St. Ann's Novena, Scranton. *Author's collection.*

closed the fissure, making the monastery grounds safe and more stable than ever before.

St. Ann's Novena began in November 1924, when a handful of people requested that the rector of the monastery hold a weekly Novena honoring St. Ann. Devotions were held each Monday and still are today. What began as a handful of people turned into a few hundred, and the crowds kept coming. Soon the facilities were too small to accommodate the growing congregation. Finally, it was decided to build a new church; ground was broken in 1927, and the church was completed on April 2, 1929. Such was the beginning of St. Ann's Shrine and Novena.

The solemn Novena in July came about not through promotion from the Passionists but rather more by word of mouth. Through the years, there have been reports of many miracles happening through the intercession of St. Ann. Many make pilgrimages during the ten-day celebration in July. It is said that there is no other shrine of St. Ann in the world that receives as many pilgrims on her feast day as St. Ann's in West Scranton.

On October 27, 1997, Pope John Paul II declared St. Ann's National Shrine a Minor Basilica. It is interesting to note that St. Ann is the patron saint of coal miners and the grandmother of Jesus Christ. Her feast day is celebrated on July 26.

PENN AVENUE BAPTIST CHURCH

In 1859, the Baptists living east of the Lackawanna River were longing for a new church. Twenty-five members of the original Baptist congregation met at the home of Nathaniel Halstead, and they began to make plans for such a church. Reverend Isaac Bevan was made pastor of what would later become known as the Penn Avenue Baptist Church.

During the time the church was being built, the congregation met for services at the Odd Fellows and Washington Halls. The dedication took place in 1861. During the ceremonies, the pastor collected $12,000, which wiped out the debt of the new building.

According to Thomas F. Murphy's *Historical Account of Lackawanna County*, Reverend David Spencer, another of the pastors of the church, gave Scranton the title "Electric City" at the time of the first electric streetcar in November 1886. One of the church pastors, Reverend F.Y. Pierce, DD, became a prominent blackboard illustrator in New York.

ST. LUCY'S CHURCH

An unsigned letter sent to the *Scranton Times* ("Police Guard House of Italian Priest") on April 25, 1907, read, "We give you [nuns] and the priest three days to leave, but if you refuse, after that the house and church will be blown up with dynamite."

This written threat was received by the Sisters of St. Lucy's Church in West Scranton in April 1907. The sisters immediately alerted the parish priest, Father Dominic Landro, to its menacing content; he, in turn, contacted the Scranton police. Superintendent Lona B. Day stationed a good number of his men for several nights outside the church and rectory in order to protect the priest and nuns. Church members in the Hyde Park neighborhood also took turns standing guard over their house of worship.

The motive behind the letter stemmed from a meeting of the male parishioners of the congregation to raise money in order to lessen the church's seven-year-old debt. At one point, the meeting came to fisticuffs when the men couldn't come to a reasonable solution, and some called for a change of priest. The day following the meeting was when the letter was received by the sisters.

Above: St. Lucy's Church in West Scranton.

Opposite: Penn Avenue Baptist Church. *Author's collection.*

Law-abiding citizens of Scranton suggested to Mayor Dimmick that a police raid should be instituted against Italians who went about the streets carrying knives, stilettos and revolvers—similar to a raid that had occurred in New York City a week earlier. The New York Police Department had arrested four hundred armed men in one day.

The *Scranton Times* reported that although there are many good Italian people in Scranton, there was a provincial hatred among them. For example, a man from Sicily would fight one from Calabria for no other reason than that they come from different parts of Italy.

Father Lando was well respected and loved by many in St. Lucy's congregation. He was appointed the church's first pastor by Bishop O'Hara in the 1890s and sought to cultivate a reverence for religion while facing many hardships at the somewhat tumultuous church.

The good priest felt that the $7,000 church debt could not go on forever and suggested a meeting of the trustees in hopes of a solution. Father Lando certainly never expected that it would result in a bomb threat. Neither he nor the nuns were scared by the letter; they placed their trust in God and felt that he would protect them.

St. Cecilia's Academy

Founded in 1872, the Cathedral School, originally called St. Cecilia's Academy, was the first Catholic school in Scranton. The academy was both a boarding and day school and taught girls from the county, as well as other vicinities in the state, under the direction of Reverend Bishop O'Hara.

The school had a reputation of excellency. It was chartered in 1883 by an act of the state legislature that enabled it to give its students the normal academic honors. Religion classes were also offered to children who went to public schools. The Sisters of Servants of the Immaculate Heart of Mary served as the teachers from the academy's genesis in 1872.

In 1941, Bayard Taylor No. 35 School was purchased and used as part of the educational facility. By 1958, its enrollment totaled six hundred students, and this hefty number exceeded the school's space. Monsignor Robert A. McNulty requested that the eighth-grade students attend the Cathedral School on Wyoming Avenue. In later years, enrollment began to decline at the downtown Cathedral School, and it would eventually close in the 1970s.

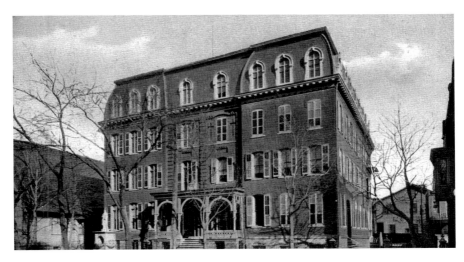

St. Cecilia's Academy was the first parochial school in Scranton. *Author's collection.*

MARYWOOD TURNS 100!

Marywood College was established on September 8, 1915, with its first class consisting of thirty-four young women. In 1924, the Liberal Arts building opened, followed by O'Reilly in 1928, better known today as Regina Hall. The beautiful Rotunda was completed in 1937.

The Congregation of Sisters, Servants of the Immaculate Heart of Mary, served as college presidents for nearly thirty years. Mother M. Germaine O'Neill, IHM, was Marywood's first president, but the actual administration responsibilities fell on the desk of Sister M. Immaculata Gillespie, IHM, PhD, who served as dean from 1915 to 1943.

Destruction struck in 1970, when the IHM Motherhouse burned down. This building had housed the college in the early years. Planning ahead for a brighter future and a rising population led to the opening of the Gillet School, the building of the Visual Arts Center and the expansion of the Human Services Center and the Health and Physical Education Center.

During Sister Mary Reap's nineteen-year-presidency, Marywood achieved full coeducational status, witnessed the construction and reconstruction of twenty-four facilities and an increase in financial donations and became the first regional institution to offer a doctoral degree program.

The transformation from college to university status occurred in 1997. In 2007, Sister Anne Munley was elected as Marywood's eleventh president,

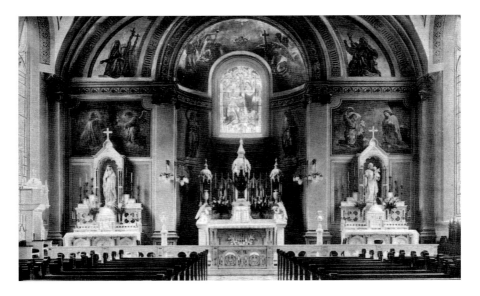

The Chapel at Marywood University. *Author's collection.*

and in 2009, northeast Pennsylvania's first school of architecture opened. On the brink of its 100th birthday, Marywood is currently building a Learnings Common, scheduled to open in the fall of 2015.

Part V

AT THE HAND OF TRAGEDY

THE FLOOD OF 1942

The horrendous flood of 1942 caused much loss and distress to a large number of people in Lackawanna County. On the night of Friday, May 22, and Saturday, May 23, a series of flash floods ravaged at least six counties in northeastern Pennsylvania. The water came to the area suddenly due to three days of heavy rain. In Hawley, twenty-five structures were washed away from their foundations, including the Hawley Ice Company. The situation was so severe that the Red Cross brought in doctors and nurses to aid the injured in their suffering, and food was trucked in to help feed the people who were left homeless.

One place that was particularly hard hit was Carbondale. The armory was completely flooded, and a break in the wall of Racket Brook Bridge caused the water to flow rapidly down Main Street. Railroad tracks were washed away in Archbald, as were dozens of bridges on numerous highways throughout the area. The rush of water was so strong that it carried the A&P Store in Archbald to a new location.

There was death and destruction on a wide scale in Hawley, and many business industries and enterprises were damaged in Scranton and Carbondale, even as far as Philadelphia. Total property damage was estimated to be between $5 million and $20 million.

The flood of 1942 left much destruction in its wake, especially in Carbondale.

The waters had begun to recede by Monday, May 25. Six hundred WPA workers and thousands of volunteers were kept busy cleaning and repairing homes, industrial plants and highways from the silt and the destruction that the flood of '42 left in its wake.

DEATH ON THE RAILS

In July 1923, a gang of bandits held up the Laurel Line train during its run between Moosic and Avoca. When the train left the station that morning, no one could have foreseen the tragedy that lay ahead. Motorman Durkin was doing his usual daily duties when he suddenly felt something pressed into his side. The man holding a revolver to his ribs ordered Durkin to stop the train. Simultaneously, at the rear of the train, the conductor was also being held up by another member of the gang. While Conductor Gleason tried to convince the robber that they were being foolish, that another train would be by any minute and that they would have no means of escape, Motorman Durkin was trying to wrestle the gun away from his assailant. *Bang*! The gun went off, and Durkin crumbled to the platform as the Laurel Line came to a screeching halt.

In the meantime, two brawny men had forced their way into the main car. One shouted to the passengers, "Put your hands up," as the other fired

off two shots. One bullet struck Mr. Edward J. Murphy, a salesman for the Maloney Oil Company; he instantly collapsed into his seat and slumped over dead. Another passenger, Arch Henshall, paymaster for the West End Coal Company, was also shot trying to prevent the bandits from taking the company's payroll, which was in three metal boxes at his feet.

The men informed the passengers that they were not there for their money or pocketbooks—"We are after the payroll and no one will get hurt, if you keep quiet." After finding what they had come for, the bandits fled the train with $70,125 to their getaway car idling nearby. Shortly afterward, their Buick touring car with license plate no. 42490 was seen traveling at an accelerated speed toward the Pittson area. Within forty-five minutes, every available patrolman and detective in Lackawanna and Luzerne Counties was on the bandits' trail, but their efforts were futile.

The robbers had escaped and left five victims: Edward J. Murphy, shot and killed; Arch Henshall, who was shot in the thigh but survived; Motorman P.J. Durkin, who was shot through the chest, with the bullet getting lodged in his lung, but he survived; Philip Scribner, who was shot in the back but survived; and Rose Kravitz, who suffered wounds to her face, head and body when she fell against the seat during the holdup. Although versions of the account vary, the names of the victims remained consistent.

As for the fates of the six Laurel Line bandits, five were eventually caught and brought to justice thanks to the valiant efforts of state police officer Lieutenant Jacob C. Mauk; he was credited for solving the mystery of the Laurel Line and for the apprehension of Tony Burchianti and Tony Torti on October 10, 1924. Both men were convicted of first-degree murder and sentenced to die in the electric chair. They were executed on June 1, 1925. Torti was the one who shot and killed Edward J. Murphy in cold blood.

"Big Jack" Stummi was mortally wounded by Lieutenant Mauk two months after the robbery when an anonymous tip led him to Stummi's whereabouts. Paul Farci was arrested in Chicago and brought back to Scranton to stand trial; he was also convicted and executed. The fifth bandit, whose name cannot be identified, was convicted and executed in another state for a different murder. Some reports claim that the sixth man involved in the robbery was executed for murder in another part of Pennsylvania, but he was never officially charged with the Laurel Line robbery.

GIBSON TRAIN WRECK CLAIMS THE LIVES OF LOCAL RESIDENTS

At 5:21 a.m. on July 4, 1912, the worst rear-end collision in railroading history up to that time happened three miles east of Corning, New York, at the Gibson Train Station.

What was supposed to be the start of a festive holiday weekend quickly turned into tragedy. The Delaware, Lackawanna and Western Freight Train no. 393 left Elmira, New York, at 3:50 a.m., right on schedule. But after experiencing some engine problems, it pulled into the siding station of the Gibson, New York station to inspect the issue. The conductor immediately threw the sign to warn oncoming trains that no. 393 had stopped on the mainline. Warnings were posted one mile east of Gibson, and a man with a red flag was stationed half a mile down the tracks to prevent the no. 9 train from crashing into the stopped no. 393. Reports stated that there was a thick morning mist from the Chemung River.

Passenger train no. 9 left Elmira at 4:47 a.m. and was headed for Buffalo and Niagara Falls with holiday excursionists from Scranton, Brooklyn, Binghamton and Elmira aboard. Despite the poor visibility conditions, engineer T.J. Hartnett pulled into Gibson, saw the warnings and began to slow down before coming to a complete stop. Hartnett was prepared to help no. 393 push the remaining cars into the siding.

Shortly after 5:00 a.m., the Delaware, Lackawanna and Western Express no. 11 left Elmira; on board was the United States mail and more Fourth of July excursionists. Engineer William Schroder, a twenty-year veteran, held the throttle as it came barreling through Big Flats at a speed of sixty-five miles per hour. Poor visibility and speed played a major factor in the following events. Simultaneously, at the Gibson Station, many of the no. 9 passengers had gotten off the train to stretch their legs and walk along the tracks while the no. 9 slowly nudged no. 393's car to the siding.

Half a mile down the tracks, flagman Edward Lane saw the impending doom. The no. 11 missed all the warning signs and plowed into the back of the no. 9, pushing it into the rear of the no. 393. Mangled bodies were strewn along the tracks in the aftermath. The horrendous wreck left thirty-nine people dead and eighty-eight injured.

Four Scrantonians were among the dead. Mr. John Zimmer, the North Main Avenue furniture dealer, and his wife, Theresa, were traveling to Michigan on a business trip. Mrs. Rees H. Jones, only twenty-four years old, was traveling with her husband; he had escaped the fate of his wife because he had left the train to buy cigars. Antonil Nopak, a new resident of the city,

was on his way to Buffalo. Another casualty was eighteen-year-old Edith Hess, who had been traveling with her father, William. In several newspaper reports, William stated:

> *Three of us strolled a little way from the train to get a breath of fresh air. We saw train No. 11 come thundering around the curve. My eighteen year old daughter, Edith, was on the day couch in the rear of the train. I tried to rush to her aid, but there was no chance. It was horrible; there were shrieks of the dying passengers pinned under the wreckage that bore no resemblance to what were once cars. Minutes passed like hours, once I collected my senses. I went to find my Edith, I found her dead and I am taking her back home with me, that is all I know.*

Edith Hess was laid to rest at Forest Hill Cemetery in Dunmore on July 8, 1912. Her viewing took place at the family home on Adams Avenue. The house was crowded with a host of family and friends. Edith was loved my many and would surely be missed.

A DROWNING IN THE CEMETERY

Jefferson Foster, a resident of Dunmore, was last seen kneeling in prayer in front of the grave of his beloved wife. Foster, who lived with his son-in-law, John Mowery, left his house one Saturday evening in 1891, never to return. Becoming worried about his father-in-law's absence at the late hour, Mowery searched and finally located him at the home of Foster's son on Blakely Street, where he remained overnight. The following morning, Mr. Foster awoke early and left the house without anyone's knowledge. Nearby neighbors witnessed him enter the Dunmore Cemetery and go directly to his wife's grave. Unfortunately, no one ever saw him leave the cemetery, and the rest of his actions can only be surmised.

It is believed that he crossed the fence that separates Dunmore Cemetery from Forest Hill Cemetery, followed the ravine and committed suicide by drowning himself in the nearby brook. Foster's family became alarmed when they awoke Sunday morning and discovered his empty bed. A search party was quickly formed; for a long while, the group of men scoured the cemetery but found no trace of Mr. Foster. As the hours ticked by

The tragic drowning of Jefferson Foster took place in Forest Hill Cemetery. *Author's collection.*

and there was still no sign of him, Foster's son sent telegrams to other family members in Olyphant and Pittston in the hopes that they might have knowledge of his whereabouts, but no one had heard from him; his son's hopes were quickly dashed.

Early the following morning, the search party combed through the woods of the cemetery once again, and at about 8:30 a.m., Elmer Setzer came upon a lifeless body lying facedown in the creek that ran through Forest Hill. Due to the shallowness of the spot, it was believed that Foster willingly held his head under the water until he drowned. All the evidence presented itself as a suicide. His coat and hat were found lying only a few feet away. The deceased's body was dragged from the shallow waters and laid on the bank. Other than a small scratch above one of his eyes, there were no other wounds found on his body, suggesting that no foul play was involved. Because of that fact, the coroner felt that no inquest was necessary. The case was closed.

Reports concluded that the motive for Foster's suicide was illness. He had been unwell for some time and was unable to work for two months before his death. Foster frequently complained about a terrible pain in his head and even went as far as speaking of suicide a means to end his suffering. Family and friends brushed it off and paid very little attention to his complaints. That was, until that tragic Monday morning when they dragged Foster's lifeless body from the brook just four days after his sixty-fourth birthday.

NOTORIOUS HANGINGS IN LACKAWANNA COUNTY

From its establishment in 1878 until 1914, Lackawanna County executed the following men convicted of first-degree murder.

The first man sent to the gallows was Crecenzo Merolo of Old Forge. Merolo killed in cold blood Emanuel Doro, his elderly barber, after arguing over his unpaid bill of fifteen cents. Merolo was hanged on July 1, 1896. Being the first hanging in the county, many people were in attendance. Newspaper accounts note that there were at least fifty or more men who witnessed the execution. The gallows were built in the corridor of the county prison rather than the customary jail yard. Frank Clemens was the sheriff and executioner.

The second man to die by the noose was George Van Horn, for slitting the throat of Mrs. Josephine Wescott at Linden Street and Franklin Avenue in downtown Scranton. Van Horn was hanged on May 4, 1899.

Savario Curcio was hanged in January 1908 for the slaying of Nicholas Ferrais in North Scranton on Christmas Eve 1905. Curcio had attempted suicide right before the date of execution, but the doctors saved him for the death decreed by law.

Perhaps the most heinous of the crimes was that of Nicholas DeMazo, another Old Forge resident. DeMazo killed his pregnant fourteen-year-old child bride after she deserted him. He was hanged on July 29, 1909.

On New Year's Eve 1908, Miss Lizzie Horvath was celebrating the holiday when her life was cut short by Shandore Fenez. Her killer was hanged on April 14, 1910.

On the night of November 17, 1911, William Peter Bishie shot and killed Irvan Borger. Bishie was convicted of murder in the first degree and sentenced to be hanged in June 1912. However, a respite was granted, and the board of pardons changed his sentence to life in prison.

John Chimielewski, a coal miner, was found guilty on May 24, 1913, for the slaying of Carbondale patrolman William McAndrew in Dickson City on January 16, 1913. Chimielewski was one of the last to hang from the gallows. In December 1914, the scaffolds were disassembled in Scranton, and from then on, the electric chair took its place as executioner.

FIRE AT ORPHANAGE KILLS SEVENTEEN CHILDREN

St. Patrick's Orphanage, located at the corner of Jackson Street and Lincoln Avenue in West Scranton, had been just recently erected in order

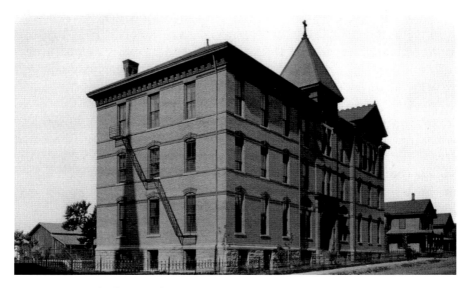

Fire broke out at St. Patrick's Orphanage in 1881. *Author's collection.*

to accommodate the increasing number of orphans in the city when a horrific fire broke out on the evening of February 27, 1881. The number of children who had called St. Pats their home at the time totaled forty. The sleeping quarters were on the third floor, with boys on one side of the building and girls on the other; they ranged in age from three to eleven years old.

On the night of the fire, Sister Lauretta had tucked in all forty children and was the last one to come downstairs from the third floor. The sister had not noted any sign of fire. As customary, the sisters met in a large room on the first floor for the evening prayers. It was then that one of the nuns smelled smoke. She immediately opened the hall door, and their worst fears were confirmed when a rush of smoke filled the room. Without hesitation, the sisters rushed to the children's aid. Sisters Mary, Lauretta and Antonia fought their way through the massive cloud of smoke to the girls' room. The nuns each carried two children back down the stairs, while the older girls were able to make their own way. Upon hearing the cries, some of the boys made it to the girls' side and followed along. The sisters brought the children outside to safety. People in the neighborhood welcomed them into their homes and out of the cold night's air, as they were in their thin bedclothes.

People in the vicinity sounded the alarm, and the news of the horrendous fire spread rapidly. A messenger was sent to the Odd Fellows Hall, where Reverend P.T. Roche, pastor of St. Patrick's Church, was attending a lecture. After learning of the fire, the pastor immediately went to the orphanage.

Meanwhile, the three sisters rushed back to the burning building intent on the saving the remaining boys, but they were stopped at the entrance by a man who refused to let them pass. He insisted that the youngsters were all safe and that there was no reason for them to risk their lives. The sisters did not know this man, nor did they know where he had come from.

"Are you sure all the boys are out?" questioned Sister Lauretta.

"They all are out. If you open this door, the flames will get air, and the whole building will be destroyed," the man answered. Despite the unknown man's reassurances, Sister Antonia raced to the rear of the building and tried to reach the boys from the stairwell, but the flames were too much. Her veil was burned, and her face was scorched. Realizing that there was no way to reach the boys from that entrance, she returned to the front doors and tried to reenter, only to be turned back by the same man.

The ringing of the general alarm brought four fire companies to the orphanage. The first companies to arrive, as well as Reverend Roche, were also told by the man that the boys had all been rescued and that the door must not be opened. When the men of the Franklin Hose Company arrived, fireman Cooney Hildebrand pushed the man aside, opened the door and ran to the boys' quarters. What they found was a horrific sight. Five of the victims had been jammed against the door, apparently trying to escape, but had been overcome by smoke, and others were lying lifeless on the floor. The bodies of sixteen boys and one girl were taken to the morgue of the undertaker Michael Wymbs. It's believed that the little girl who perished had gotten confused in all the excitement and lost her way. The undertaker confirmed that the children died of suffocation.

The cause of the fire remained a mystery for a long while. The gas jets were found in good condition, and the sisters stated that no lighted lamps were carried at any time. Later, it was discovered that a young woman employed by the orphanage had gone into a clothes room with a lit candle and accidently forgot it when she left the room.

Several days after the fire, Coroner Nathan G. Leet conducted an inquest. The jury found that no blame could be placed on the nuns—that they and Reverend Roche did everything humanly possible to save the children. However, the jury stated, "We do censure the over officiousness of the

unidentified man who assumed to dictate to inmates and firemen, thereby obstructing the saving of lives and property."

Their hearts stirred by the tragedy, men and women of every religious background contributed to the rebuilding of the orphanage on the same site. As for the identity of the man who allowed those poor innocent children to perish, Fire Superintendent Henry F. Ferber said that he knew the man and gave the jury his name at the coroner's inquest. But the man denied Ferber's statement, declaring that he was not at the orphanage on the night in question and calling it a case of mistaken identity.

HIS CONSCIENCE TOLD HIM TO KILL HER

It happened on March 25, 1928. Thirty-five-year-old Russel McGarrah brutally murdered his wife in their Green Ridge home. The heinous act sent shock waves throughout the county. McGarrah was a member of a prominent Scranton family. His father, William, was a druggist noted for manufacturing McGarrah's Insect Powder.

Local newspapers reported that McGarrah committed the crime less than two hours after he and his young wife, Dorothy, received the Lord's Sacrament at Asbury United Methodist Church. Upon leaving the church on that ill-fated Sunday, the couple left their only son, Jack, in the care of Russel's sister and then returned to their home. McGarrah claimed to have seen a piece of white rope lying on the davenport in their living room, and this stirred in his mind the thought that his wife was planning to strangle him, a thought he had become increasingly obsessed with over the past several weeks.

As per his confession, the couple sat together in the living room quietly reading for quite some time before the gruesome event took place. At about 2:00 p.m., Dorothy rose from the couch and started to walk toward the kitchen, with her husband following closely behind. From a drawer in the kitchen, Russel grabbed a butcher knife and, without so much as a word, stabbed Dorothy twelve times in various places on her body. A slash of the knife that severed the upper region of her heart was the one that caused her to die instantly. The tip of one of Dorothy's fingers had been severed in her attempt to save her life.

Three more hours passed before Russel sought out Reverend Nicholson of Asbury United Methodist church in order to make a confession. Upon

hearing the horrendous details, the reverend advised McGarrah to turn himself into the authorities, which he readily did without a fight.

The Scranton police discovered Mrs. McGarrah's body lying in a pool of blood. The piece of white rope with which McGarrah claimed his wife was going to kill him was never found. Family members and friends were shocked and saddened by the grisly news. Those closest to the couple felt that there wasn't a motive for the slaying—the McGarrahs had an ideal home life. But the authorities came to learn that Russel had suffered a nervous breakdown the year before; he was forced to quit his job and was never really quite the same.

Detective A.J. Reilly stated that McGarrah expressed no remorse for his actions during the interrogation; he appeared well rested and was hungry and anxious for a cup of coffee. While being questioned by the detective, he kept uttering, "I feel I did right, I did what my conscience told me, it was either her or me."

Russel McGarrah was held at the county jail on the charge of murder; a conviction was inevitable. He spent the rest of his life in a mental institute for the criminally insane.

THIRTY THOUSAND POUNDS OF BANANAS

A fatal accident took place on March 18, 1965, at the southwest corner of Moosic Street and South Irving Avenue. A thirty-five-year-old truck driver, Eugene Sesky, was on his way to deliver a load of bananas to Scranton merchants. He was driving a 1950s Brockway diesel truck tractor with a thirty-five-foot semi-trailer. As he was heading down Route 307, he lost control of the vehicle. The truck made a two-mile descent from Lake Scranton to the bottom of Moosic Street and eventually crashed at the corner of South Irving Avenue. Details about the cause of the accident are somewhat vague; it was assumed that the driver experienced brake failure because of the truck's ninety-mile-per-hour speed coming down the hill. He sideswiped a number of cars before he crashed. Witnesses at the scene suspect that Mr. Sesky deliberately flipped the truck to avoid killing pedestrians and other motorists or running into the nearby gas station; if it had exploded, the loss of life would have been even greater. Bananas were strewn everywhere; the road was closed, and cleanup took many hours. Since the accident, trucks over twenty-one thousand pounds are not permitted to travel that route any

longer. Mr. Sesky gave his own life to save others; he is a hero to many, and people have made numerous attempts to get a historical marker dedicated to him. To date, all attempts have been unsuccessful.

After being told the story while he was on a Greyhound bus, the late singer Harry Chapin wrote a song entitled "30,000 Pounds of Bananas." Originally it was a poem that Harry wrote due to his preoccupation with numbers. The late Chapin's wife, Sandy, did not like the song, and the singer was criticized by others for being insensitive because it had been recorded less than ten years after Sesky's death.

Chapin had promised to donate proceeds from the royalties to Mr. Sesky's widow and children, but instead they went to his own campaign against hunger.

CARBONDALE FIRES

The first major fire in Carbondale occurred in 1850, running from the parade grounds on the east side of Main Street and the west side of Church Street. It destroyed much of the business section and wiped out many

A fire destroyed a major section of Carbondale's business district in 1955.

landmarks and monuments. It was reported to have started at the home of G.W. Thomas.

Five years later, W.W. Bronson's Railway Hotel was destroyed along with other businesses on the east side of Main Street. In 1859, the courthouse was hit by flames. The courthouse was also used as a jail, and at the time of the fire, a cell was occupied by a man who had been arrested for public intoxication. As he awakened from his drunken stupor, he tried to light his pipe but instead he set fire to his bed and met a horrible death.

The next notable fire broke out in Alfred Darte's office; the flames also burned the Harrison House and traveled north along Salem Avenue. Once again, in 1866, a major fire burned many buildings on the Main Street, east from Salem Avenue to the parade grounds.

The entire business district in the city went up in flames on March 29, 1867. The fire destroyed forty stores and shops and left sixty families homeless. Carbondale residents are resilient, though. They were not daunted by the destruction, and instead they built new buildings and homes out of the ruins.

Part VI
NOT-SO-QUIET RIOTS

STRIKE OF 1870–71

The strike in the northern field lasted from December 1870 to May 22, 1870, and was often referred to as the "six-month strike." On January 10, 1871, the Workman's Benevolent Association ordered a general strike for the entire region. This strike was disastrous for everyone involved. By the spring of that year, the miners were becoming discontent with the situation, and tempers were starting to get the best of everyone. When several collieries resumed work during the strike, riots began to break out and soldiers were brought in to curb the lawlessness that ran amuck in Scranton. But before it was all over, there would be bloodshed.

On the sixth of April, a mob became unruly at the Tripps Slope at the end of work day on Good Friday; a breaker in the Notch section of the city was burned down, and armed strikers and sympathizers took to the streets, beating up workmen who were considered "scabs" for returning to work during the strike.

The most violent events occurred late in the day on May 17. A group of thirty or more workers was being escorted home by a company of Zouaves and W.W. Scranton when they were met by a riotous mob of four hundred just east of South Main Avenue and Luzerne Street. Stones and other objects were thrown at the soldiers and miners, and one of the stones hit a Zouave named Cairus. Without warning, the militiamen shot into the crowd, and

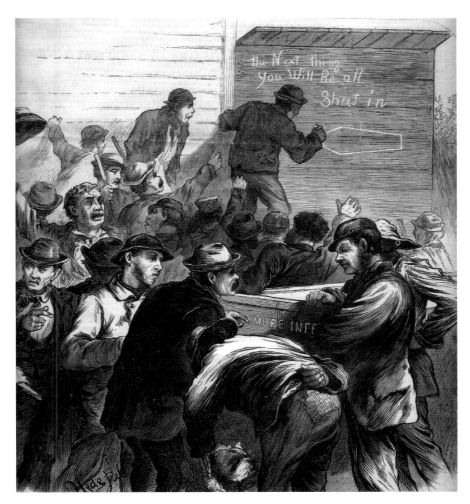

Illustration of the strike of 1871. *Author's collection.*

two men, Benjamin Davis and Daniel Jones, fell dead. They were standing behind each other, and the Minié ball from Cairus's rifle went through Davis's body into Jones's. W.W. Scranton ran to the front of the crowd and shouted, "Don't fire boys, that will do."

Many felt that Davis and Jones were both innocent and not involved in the mob, while members of the Zouaves insisted that one of the men shot had thrown the stone that struck Cairus. Some years later, a person who witnessed the incident said that the promptness of Mr. Scranton prevented what would have been an appalling slaughter.

Five days after the two men were killed, the strike was called off, and on May 28, the militia left the city.

Riot on Lackawanna Avenue

On August 1, 1877, a riot occurred at the intersection of Lackawanna and North Washington Avenues. It was the result of our nation's labor unrest. Earlier that summer, a 10 percent wage cut caused the Great Railroad Strike of 1877. All trains stopped, and the lack of transportation forced the mines to close because there were no means to get the coal to market. Lack of work left the miners and their families desperate, hungry and frustrated by the capitalists' absence of concern for the very workingman whose blood and sweat had made them rich for many years. By the end of July, the railroad workers had returned to work without so much as a penny increase to their wages. The miners felt betrayed and arranged for a meeting on the morning of August 1 at a silk mill on the south side of the city.

By eight o'clock that morning, the temperature had already reached ninety degrees, and tempers were high before the meeting even began. The reading of an anonymous letter allegedly written by William Walker Scranton, general manager of the Lackawanna Iron and Coal Company, set the miners off like a match to a powder keg. The letter stated that Mr. Scranton intended to cut the wages of the workingman even more, down to thirty-five cents per day. With a reported three thousand to five thousand men in attendance, an unruly mob quickly formed and headed for Lackawanna Avenue. Armed with bats and big wooden sticks, it was clear what the angry mob intended to do once it reached the shops that lined Lackawanna Avenue.

At the intersection of Lackawanna and North Washington Avenues, the people were met by Scranton's mayor, Robert H. McKune, and Father Dunn from the St. Peter's Cathedral Roman Catholic Church. The mayor had already been alerted to the angry mob by one of his men, who had business on the south side, that morning. Days earlier, when riots had broken out in Pittsburgh and Philadelphia, Mayor McKune had deputized one hundred or so men to act as secret police in order to defend the city at the first sign of trouble. He was prepared, or so he thought. Both Mayor McKune and Father Dunn urged the crowd to cease and desist; their requests were greeted with jeers. One man in front of the crowd struck the mayor with a pipe, breaking his jaw.

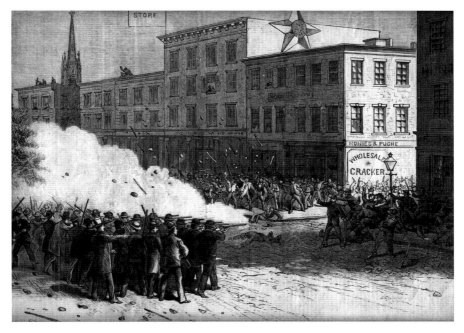

A drawing depicting the riot on Lackawanna Avenue in 1877. *Author's collection.*

The mayor's secret police, better known as the Scranton Citizen Corp, and twenty-five of W.W. Scranton's men came marching down Lackawanna Avenue to the intersection. Mayor McKune was somehow able to yell, "Fire" despite his broken jaw, and shots immediately rang out, with bullets pelting M&P Bakery and Hunt's Hardware. Three men fell dead, and another victim would die days later. How many people were wounded or killed that hot August day no one knows for sure. People did not want to admit to being a part of the unruly mob. Within three minutes of that first shot, the crowd dispersed. Lackawanna Avenue would be stained red with the blood of the workingman forever.

DEFENDERS OF OUR CITY

In the summer of 1877, our nation was in a state of labor unrest. All trains had stopped, and for the first time in history, our nation's transportation system was paralyzed by strikes. During this tumultuous

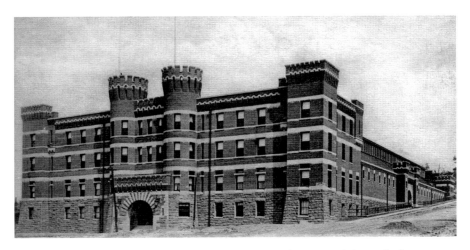

The Thirteenth Regiment Armory on Adams Avenue in Scranton. *Author's collection.*

summer, Scranton had been the only city able to contain the rioters without any outside help from federal troops. Many thought that quite impressive, so much so that the small group of local deputized citizens soon grew to more than two hundred. On August 14, 1877, the city guard was officially formed. Henry Martyn Boies, president of the Moosic Powder Company, was appointed commanding major. There would be a battalion of four companies—A, B, C and D—and they were mustered into service of the State of Pennsylvania as part of the National Guard under the title of the Scranton City Guard.

Boies, along with Reverend Samuel C. Logan of the First Presbyterian Church, was chosen to secure land on which to build an armory. They purchased two lots from the Susquehanna and Wyoming Valley Railroad and Coal Company on the east side of Adams Avenue between Linden and Mulberry Streets. The armory was completed on January 31, 1878.

Shortly afterward, the legislature of 1878 passed an act reorganizing the militia of the state, which meant that battalions and companies would now be consolidated into regiments. This act would bring an end to the Scranton City Guard as a separate entity. But it would be the beginning of a new chapter. Because there were already enough companies, permission was granted to organize a regiment, and its headquarters would remain in Scranton. On October 19, 1878, the company was mustered into service as the Thirteenth Regiment, National Guard of Pennsylvania.

In 1899, it became evident that larger quarters were needed. The new armory was built from funds subscribed independently of the proceeds

from the old armory. A tract of land from Jefferson Avenue to Adams Avenue was purchased, and this would become the Thirteenth Regiment's new home.

The following is an article from the *Scranton Times*, dated November 3, 1900:

> *The cornerstone of the new armory was laid by H.M. Boies at 11:30 this morning in the presence of the trustees. Mrs. Boies pronounced the stone plumed and true. Dr. S.C. Logan offered prayers. There was no military demonstration. A red copper box containing the cornerstone of the old armory (1878), records of the 13th Regiment and copies of local daily papers were placed in the new cornerstone.*

To note, the red copper box mentioned in the article was discovered and the time capsule opened in 2013.

MINERS AWAIT STRIKE

Almost 500,000 coal miners went on strike when wage negotiations broke down. President Roosevelt's radio address urged the miners to radiate their union's call to strike. The miners' typical sentiment was reflected in this statement: "He was a hero to us back in '32, and I was for him in '36 and '40. But I'm against him now. He's on the side of the operators and the War Labor Board now."

Negotiations began in March 1943, and there was much confusion as to the source of the resistance to a wage increase. The CIO and AFL blamed the War Labor Board and vice versa. On May 1, 1943, nearly 500,000 coal miners went on strike when the United Mine Workers contract expired. The strike paralyzed the nation's coal industry overnight.

John L. Lewis, leader of the United Mine Workers, met with the coal operators in an attempt to end the wartime strike. His critics complained because Lewis had been a thorn in President Roosevelt's side during World War II. At the start of this decade's labor unrest, FDR seized the United States' coal fields on May 1, 1943, and forced Lewis to cancel the strike set for the following day.

This event resulted in Congress passing the Smith-Connally Anti-Strike Act. Lewis went against the no-strike pledge in 1942, which was intended to

Miners have a drink in a Carbondale bar as they await a decision to strike. *Author's collection.*

last throughout the war. At that time, Lewis did win a wage increase for the nation's coal miners.

The following is an excerpt from President Roosevelt's address to the miners on May 2, 1943:

> *Every coal miner who stopped mining coal no matter how good his or how strong his grievances may be obstructing the war effects. A stopping of the coal supply even for a short time, gambles with the lives of American Soldiers and Sailors and the future security of our whole people. Therefore I say to all miners, and to all Americans everywhere at home and abroad, the production of coal will not be stopped. The responsibility of this crisis rests on the nation's officers of the United Mine Workers and not the United States Government. But the consequences will threaten all of us everywhere. On Saturday May 1st, the Government took over the mines. Tomorrow the stars and stripes will fly over the coal mines and I hope that every miner will be at work under that flag.*

Despite the president's urgent request, most miners did not return to the mine until June, when negotiations for a wage increase resumed. Only fifteen thousand workers returned after FDR's address, which in turn closed the steel mills for two weeks, causing power shortages that hurt the war effort.

Part VII

MEDICINAL PURPOSES

LOCAL CONSUMPTION HOSPITAL FIRST OF ITS KIND IN STATE

West Mountain Sanatorium was established on January 26, 1903; the land had been donated by the Delaware, Lackawanna and Western Railroad. Its original name in the early days was the Scranton Society for the Prevention and Cure of Consumption (better known today as tuberculosis). The hospital was the first of its kind in the state. It used state-of-the-art equipment and was said to offer the best treatments, which required its patients to remain outdoors in the screened porches for extended periods of time, even on the coldest days of winter. The healing process was believed to cleanse the body of germs and viruses.

The hospital accepted patients in all stages of tuberculosis. The year the facility opened, the bed capacity was between eighteen and twenty; by 1919, it had risen to twenty-nine. It never housed more than one hundred patients at one time.

In 1913, the total number of people who entered the hospital for treatment was fifty-eight. Of these, four patients were cured, four died, twenty improved, two worsened and thirty were discharged.

Dick Smith, a Honesdale native and notable songwriter, entered the facility in 1931. During his stay, he penned the lyrics of a well-known song. He had been influenced by his winters in Honesdale. Mr. Smith died

West Mountain Sanatorium treated patients with tuberculosis. *Author's collection.*

of tuberculosis in 1935 at the age of thirty-four, but his song, "Winter Wonderland," did not reach popularity until 1945.

Over the years, West Mountain Sanatorium has gone through its share of renovations and expansion projects; it maintained its own laundry and farm and employed a staff of forty-five.

Rumors circulated for many years that the sanatorium had been a victim of a horrendous fire that killed more than one hundred people, but no evidence has ever been found to validate the stories. Still, ghost hunters find West Mountain to be a haven of hauntings, and many paranormal events have taken place there.

Today, the sanatorium is a mere shell of its former self due to vandals and various fires started by arsonists. West Mountain officially closed its doors in 1974.

DOCTOR! DOCTOR!

Nathan Y. Leet was one of the busiest surgeons between New York and Chicago. He was a soldier in the Civil War, after which he relocated to Scranton, where he became the primary surgeon for many companies, including the Delaware, Lackawanna and Western Railroad Company. Dr. Leet also served for many years as surgeon-in-chief for Moses Taylor

Hospital. For a period of time, he was the coroner of Lackawanna County. He enjoyed phenomenal success in the treatment of fractures by what was considered the "old method." Legend has it that Dr. Leet was called to President James A. Garfield's bedside when he was shot in 1881 by Charles Guiteau, but my research on the subject as not been able to prove or disprove this claim.

James Lenox Rea was educated at Jefferson Medical College. During his career in Scranton, he served as a physician for the State Hospital and the Oral School. He was also a surgeon for the employees of the Delaware, Lackawanna and Western Railroad. He was a member of the Lackawanna Medical Society and the American Medical Association.

Samuel P. Longstreet was born in Wayne County and educated at New York University. Dr. Longsteet was both a surgeon and physician. He is noted for being the founder of the Anatomical Society.

Dr. Isaiah F. Everhart, like many of his counterparts, served as a surgeon in the Civil War. During the coal strikes of 1871–72, he was the surgeon for the Ninth Pennsylvania National Guard. Dr. Everhart traveled extensively all over the world, and for forty years, he collected specimens of natural history specifically within Pennsylvania. Isaiah Everhart financed the building of a general museum to which he donated his entire collection. The Everhart Museum is one of Scranton's most beautiful landmarks.

PIONEER FEMALE PHYSICIANS

From the time the city of Scranton was incorporated in 1866 until its 100th anniversary, there were thirteen women who practiced medicine. The first female pioneer physician in the Lackawanna Valley was Mary C. Nivison. She opened her practice in Scranton in 1871; Dr. Nivison specialized in obstetrics and diseases of women and was considered one of the best in her field. Dr. Anna C. Clarke, the dean of local women physicians, shared a practice with Nivison until she opened her own office on Jefferson Avenue, where she practiced for almost sixty years. Nivison and Clarke were sister-in-laws.

Dr. Gisela Von Poswick was one of a small few to be appointed a member of the Third International Congress of Radiology in Paris during the 1930s. Dr. Nellie G. O'Dea trained for three years at the Allentown

Hospital before opening a practice in Scranton in 1918. Doctors ran in the O'Dea family, as two of her brothers were also prominent physicians. The borough of Taylor had Dr. Helen Houser, who was the leading physician for many years. The daughter of a doctor, Houser was also in charge of the state clinic in Old Forge and the medical examiner for Benton and Abington Township Schools.

Dunmore native Dr. Nellie M. Brown opened her offices in the Medical Arts Building in 1931; she also taught medical courses at Marywood College, as it was not yet a university. Dr. Rose Greenburg opened her office in her home on Madison Avenue, while Dr. Anna Levy Levitsky moved her practice from Scranton to Newark, New Jersey.

Leading Scranton physician Pauline Kiesel Helriegel was the daughter of Dr. Ernest Kiesel and the wife of Dr. J. Curtis Helriegel; with a degree in pediatrics, she took care of many of the city's children before relocating after World War II to Rochester, New York.

Dr. Clara Raven was not originally from Scranton; she was born in Youngstown, Ohio, and was a graduate of Northwestern School of Medicine in 1936. Raven joined the pathology staff at the Scranton State Hospital and remained there for four years. She joined the Army Medical Corps in 1943 and became the chief of laboratory at the 279th State Hospital in Berlin, Germany. Dr. Raven is known for being the only American female pathologist in the Europe Theater during World War II.

The last three, Drs. Gladys Ball, Vera Sorokanich and Josephine Favini, all had medical practices in and around the Scranton area for many years.

HILLSIDE HOME

On April 9, 1862, a law was enacted by the legislature to authorize the erection of a poorhouse by the borough of Dunmore, Scranton and the Township of Providence. The first commissioners were Edward Spencer of Dunmore, Joseph Slocum and David K. Kressler of Scranton and Henry Griffin of Providence. In June of the same year, the district purchased a 127-acre farm from Abraham Polhemus for the sum of $6,730.50. This stretch of land was located in Newton Township, nine miles from Scranton on the old turnpike from Clark's Green to Newton Centre. Since the first purchase, there were several more made, making a total of 500 acres on which twenty-eight buildings and a large concrete dairy barn was built. The first

The Hillside Home is now the Clarks Summit State Hospital. *Author's collection.*

almshouse was built in 1863 and stood west of the asylum; a basement was added and used for patients that suffered from epilepsy. Another almshouse was erected fifteen years later and was used for the insane and mentally challenged inmates.

Due to the rapid increase of the mentally insane clientele, eleven acres were enclosed and temporarily devoted just to their care. The directors unanimously decided that the sane and insane inmates should be separated. For this reason, another site was chosen, about one thousand feet away from the original asylum, for the erection of a new facility. E.H. Davis was chosen as the architect, and the building was complete and occupied by autumn of 1906.

The Asylum and Hospital for the Insane consisted of a group of buildings enclosed by an iron fence eight feet high that was always under lock and key. The institution could hold up to five hundred patients; men and women occupied separate wards, as did the violently insane.

The first superintendent was William Cole from July 1, 1862, to January 1864, but much praise was given to Superintendent George W. Beemer for his excellent management skills and the manner in which he carried out the improvement of the Hillside Home. The name was changed to Clarks Summit State Hospital on October 1, 1943, when the Department of Welfare assumed the responsibility to operate and manage state mental hospitals.

EARLY EPIDEMICS

A record kept by medical pioneer Dr. Benjamin Throop mentions an outbreak of malignant scarlet fever (scarlatina) during 1842 and 1843 in Lackawanna Valley. A decade later, it resurfaced with a vengeance, claiming the life of one of Dr. Throop's own children. Carbondale suffered through the black fever in 1864, killing four hundred people in the Pioneer City. In 1871, meningitis took many victims in both Scranton and Carbondale. The Electric City was also no stranger to smallpox; the disease kept reoccurring from 1860 to 1903. Smallpox was eventually eliminated with the discovery of a

Dr. Benjamin Throop lost one of his children to an epidemic of scarlet fever (or scarlatina).

vaccine. The start of the 1890s brought about the grippe, another name for the flu, and typhoid fever hit Scranton in 1906, resulting in 1,141 cases and 108 deaths. It is believed that the city's water supply was the culprit, and the Elmhurst Reservoir was closed and all the public taps shut off to prevent further infection.

Cholera first appeared in Europe and Asia between the years of 1831 and 1832. By the end of the nineteenth century, the disease—which caused violent cramps, dehydration and diarrhea—had killed thousands of people both here and abroad. In very early times, malaria was prevalent in the valley, but it was later eradicated because its carrier, the *Anopheles* mosquito, could not survive in water contaminated by the sulfur runoff from the local mines.

Many are familiar with the influenza of 1918; it swept through the valley, with 6,644 cases reported and 1,024 deaths. The Thirteenth Regiment Armory became a makeshift emergency hospital. Two years later, there was a reoccurrence of the dreaded disease, and it claimed another 120 lives before taking its leave.

DR. EMMETT O'BRIEN

Dr. Emmett O'Brien was the youngest telegrapher to serve during the Civil War. He entered the Military Telegraph Corps in January 1862, just three months after his thirteenth birthday. Prior to that, he worked by sound on the railroad since the age of nine, making him the youngest telegrapher in the world.

Dr. O'Brian served with the Army of the Potomac, was a cipher operator for General Schofield in the last campaign and was the last field operator retained at the war department during the close of the war. Through his year of service, he met Generals Grant, Meade, McClellan, Seward, Butler and Sherman. He had also been in the company of President Abraham Lincoln. The war took O'Brian to Forts Monroe and MaGruder, Cold Harbor and Petersburg. The Military Telegraph Corps disbanded on December 3, 1865, but kept a skeleton crew on in the war office. John stayed for at least another year.

Having witnessed so much death at such a young age, John made saving lives his lifelong ambition. After the war, he was educated at the Medical Department of Georgetown College and at Rush Medical College in Chicago. Upon graduation in 1869, Dr. O'Brien was appointed a lecturer in Rush Medical College and assisted during the Great Chicago Fire of 1871, after which he moved to Scranton.

Dr. O'Brien was one of the first surgeons of Lackawanna Hospital, and it is believed that he performed the first amputation in the facility. He was the second health officer of Scranton and is remembered as having prevented an outbreak of smallpox by vaccinating seven thousand people using a more economical and efficient method that had not been tried elsewhere. He was a surgeon in the Thirteenth Regiment, Pennsylvania National Guard, for three years and contributed to medical and general literature in journals of worldwide circulation, including the text he penned about his service in the Civil War entitled "Telegraphing in Battle."

The doctor died from complications due to a heart condition on the morning of June 14, 1922, Flag Day.

THE RED CROSS

The Red Cross was founded by Clara Barton and associates in Washington, D.C., on May 21, 1881. Miss Barton first became aware of the organization while visiting Europe after the Civil War. Upon her arrival home, she campaigned for an American Red Cross and was at the helm of the

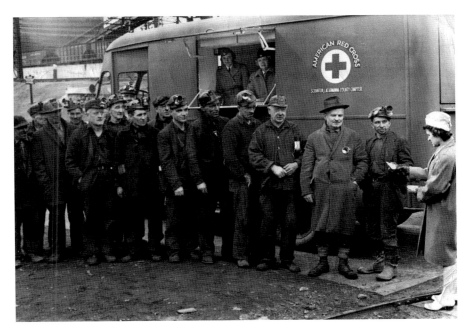

Coal miners pictured with a Red Cross volunteer.

organization for twenty-three years. The Red Cross received its first Congressional charter at the turn of the twentieth century and its second in 1905, the year before Barton resigned from the organization.

Before World War I, the Red Cross offered first aid, water safety and health nursing programs to the public. After the war, the organization centered its attention on taking care of the veterans, nutrition education and home care for the sick. It provided help for victims of major disasters and the downtrodden during the Depression.

The Red Cross enrolled more than 104,000 nurses during World War II and shipped more than 300,000 tons of supplies overseas. The military requested that it initiate a national blood program, and it was able to collect 13.3 million pints of blood.

Today, the Red Cross continues to provide services to the members of the armed forces and their families, blood collection, health and safety education and international relief. The American Red Cross of Lackawanna County is one of thirteen chapters that provide disaster relief and training to northeastern Pennsylvania communities. In Scranton, its headquarters is located on Jefferson Avenue, and Carbondale has a chapter on Dundaff Street.

Part VIII

HISTORICAL POTPOURRI

RINGING IN THE NEW YEAR, 1913!

With the end of 1912, the nation was still reeling from the horrific sinking of the RMS *Titanic*, which claimed the lives of more than 1,500 people. Many in our city were also still mourning the loss of loved ones in the Fourth of July Gibson train wreck. Tragic events like these had people singing "Auld Lang Syne" at midnight on January 1 with hopes of a brighter year ahead.

So, what made news in 1913?

- Harry Houdini introduced the legendary Chinese Torture Cell.
- The United States Post Office began its parcel post service.
- The Century Club of Scranton was built on Jefferson Avenue.
- Dancer Millie C. DeLeon, considered the "Queen of American Burlesque," was in Scranton performing a routine entitled "The Girl in Blue" at the Star Theatre on Linden Street. The dancer's appearance upset many who were considered to be of high morals in the city. But the show still went on despite their objections.
- Scranton native Finners Quinlan was twenty-five years old when he began playing major-league baseball on September 6, 1913, with the St. Louis Cardinals. He was an outfielder with a batting average of .183.

His baseball career ended because of an injury he sustained during World War I.

- St. Ann Maronite Church, located on the corner of Sumner Avenue and Price Street, was dedicated on August 24, 1913.
- In weather-related news, a record high of ninety degrees was set on September 4, 1913.

HISTORY OF THE SALVATION ARMY

The Salvation Army began its operations in Scranton in 1885. In 2013, the organization celebrated 128 years of service in our community. However, the organization was originally founded in 1865 in London by a minister named William Booth and his wife, Catherine. Booth took his ministry to the streets and preached to the hungry, the homeless and the poor. Church leaders did not approve of Booth's methods; as a result, he and Catherine left the church and sojourned throughout England, conducting evangelistic meetings along the way.

The National Casket Company was once the headquarters of the Salvation Army.

William and Catherine brought hope to the congregations, which were mainly made up of the poor and the destitute. Among Booth's first converts to Christianity were thieves, prostitutes and drunkards. His ultimate goal was to lead these people to Christ and get them into a church for spiritual help. Unfortunately, many of the churches did not approve of Booth's converts because of their unsavory pasts. Because of this, Booth continued to minister to his converts in his own way and encouraged them to help save others like themselves. Soon they were preaching and singing in the streets, and "Booth's Army" grew stronger.

In 1879, the Salvation Army found its way to the United States. Lieutenant Eliza Shirley, formerly of London, held the first meeting of the Salvation Army in Philadelphia. The Salvationists were well received at the meeting, so much so that Lieutenant Shirley wrote to William Booth for reinforcements. None was available at the time, and it took almost a year for him to send a group to pioneer his work on this side of the pond. From then on, the movement expanded rapidly. Today, the Salvation Army can be found in almost every part of the world.

Hidden Treasure in Newton

According to historian Dr. Horace Hollister, there is a tradition of an Indian gold spring in Newton where the Native Americans were able to obtain precious metals. The following is an excerpt from Hollister's *History of the Lackawanna Valley*:

> *In 1778, a young man who had been captured in Wyoming Valley was carried to the top of a mountain where the Wilkes-Barre settlement could be seen in the distance. Here they built their camp fire. A transaction took place at this time which from its novel character excited the surprise and ever afterward impressed the mind of the young, unharmed captive. A venerable chief, to whom the young man owned his safety, and subsequently his release, removed a large stone covering the spring. The waters of this were so conveyed by a subterranean conduit, constructed for the purpose, as regard to the real source of the spring. At its mouth a roll of bark forming a sprout was placed in such a manner as to direct the current into a handkerchief held under it by two of the Native Americans. For some moments the chief reverently attended by the warriors arrayed with bow and arrow and forming a circle around him stirred up the spring with conscious knowledge of its gainful results. After an hour elapsed, every stone previously disturbed was restored to its former condition; earth and leaves were left as if never touched, and no one without ocular knowledge would suspect the existence of a water-course. The handkerchief covered with yellow sediment was now lifted with the spout. The glittering product thus gathered by the chief was placed in a stone vessel with great care. After the fire was extinguished and certain incantations performed with ceremonial exactness, the Native Americans left the spot in charge of the wild rocks surrounding it, and*

resumed their march towards their land of maze among the lakes. A six day walk led the party to Kingston, New York, where the treasures of the mountain thus artfully obtained were exchanged for goods. In after years the returned hero often related the incident to family and friends, some of who traversed every portion of Bald Mountain and Campbell's Ledge without discovering the secret channel of the golden spring.

Over the years, many explorers have searched every side of Bald Mountain for the hidden treasure, but it has not yet been found.

HOME OF THE CLUB BURGER

When's the last time you paid fifteen cents for a hamburger and a dime for fries? Probably not since Carrols Restaurant closed its doors. In the late 1950s, Herb Slotnick brought fast food to Syracuse, New York, after he approached Tastee-Freez about opening up one of its new midwestern chain of restaurants called "Carrols." When Tastee-Freez went under, Slotnick took control of the entire Carrols chain and turned it into a company, which also included his string of theaters.

Carrols, "Home of the Club Burger." *Author's collection.*

Locally, we had a Carrol's Drive-In on Blakely Street in Dunmore; one in Minooka at 3110 Pittston Avenue, where Community Bank is now; and one in Eynon, across from Sugerman's Department Store. Later in the '70s, another was opened on South Main Street in Old Forge.

The restaurant's flagship sandwich was the Club Burger. Can you remember how good that secret sauce tasted slathered on the double-decker sesame seed–topped hamburger bun? The secret sauce actually has a name, Crisbo Royale Sauce; its recipe is a mixture of ketchup, mayonnaise and relish, but no one seems to know the exact proportions of the condiments. Some of the other items on Carrol's menu included the Sea Fillet, Roast Beef Hero, Crispy Country Chicken and its famous Triple-Thick shakes, for which you had a choice of vanilla, chocolate or strawberry.

All of Slotnick's 130 Carrol's Restaurants thrived during the 1960s and early '70s, but by 1975, the Club Burgers and Sea Fillets were gone; in their place came the Whoppers and Whalers. Due to overwhelming competition from other national chains, Slotnick cut a deal to transform his restaurants into Burger Kings, and the "Home of the Club Burger" became the home of the Whopper.

By 1978, Carrol's in Minooka and Dunmore were nothing more than a tasty memory; however, the restaurant in Old Forge remained and is still there today, having been converted to a Burger King in the '80s. After the U.S. conversion to Burger King, the Carrol's brand moved oversees to Finland, where it survived until 2002.

Personally, Carrol's will always hold a special place in my heart. It brings back a lot of childhood memories, good memories—the kind you never forget. Okay, now who has a hankering for a Carrol's Club Burger?

BURIED HISTORY

Much of Lackawanna County's history can be found beneath the soil of its many cemeteries.

Forest Hill Cemetery in Dunmore is the eternal resting place for many of our city's pioneers, such as members of the Tripp family; George Sanderson, developer and founder of Green Ridge; and William Connell, coal mine owner and nineteenth-century entrepreneur. The cemetery was established in 1870. George Sanderson, J. Gardner Sanderson and Charles du Pont Breck served as the first trustees. The fifty acres of land that those men

secured were located partially in Dunmore and partially in Green Ridge. Meadow Brook, which flows through, and the beautiful flora and fauna make a perfect setting for the rustic cemetery.

The Washburn Cemetery, also known as the Washburn Street Cemetery or Welsh Cemetery, is where 61 of the 110 victims of the September 9, 1869 Avondale mine disaster are buried. Near the entrance stands a marker that was dedicated on October 14, 1994, by the National Welsh-American Foundation.

Potter Cemetery, located in Elmhurst, is the resting place of Asa Cobb and his wife, Sara. Asa passed away in the early 1800s and is the namesake for Mount Cobb. Also buried there is Elisha Potter, one of the area's earliest settlers.

The Taylor Memorial Cemetery is one of the oldest landmarks in the Triboro area. It was originally part of a farm used by its owner for family burials. The oldest-marked grave in the cemetery belongs to Thomas Y. Atherton, who passed away on March 25, 1834. Some other outstanding residents include the legendary Parley Hughes, veteran of the Revolutionary War; Eliza Pulver, schoolteacher to President Grover Cleveland; and Eleazer Atherton, one of Taylor's founding fathers.

Like Washburn, the Petersburg Cemetery in Scranton was known by other names; originally, it was the Petersburg Protestant Cemetery and also the East Mountain Protestant Cemetery. Aaron Silkman sold the plot of land for one dollar to James Churchill, Nathaniel Thomas, John Shat and William Stone. The cemetery was used for interments from 1853 to 1931. John Peters was one of the cemetery's earliest burials, and Petersburg bears his family's name.

THE MORTICIANS

Funeral homes did not come into existence until the late nineteenth century. Funerals during that period were different from today's practices. If the person died at home, the body would be removed, embalmed and then returned to the home for a wake, or "sitting up," and services.

In the early 1900s, the casket would normally be placed in a horse-drawn carriage with windows on the side and driven to the cemetery. Sometimes the casket would be carried by people such as family members and friends. An account by an undertaker during the 1918 Spanish flu epidemic noted that he often drove the hearse straight to the homes to remove the bodies.

An advertisement for Musso's Funeral Home in South Scranton. *Author's Collection.*

According to the 1921 book *Funeral Management and Costs*, written by Quincy L. Dowd, the average cost for a 1918 funeral service was about $150 and included the following:

- *Casket—$65.00*
- *Care—$10.00*
- *Preservation of Remains—$10.00*
- *Shirt, slippers and so on—$6.00*
- *Blankets—$6.00*
- *Hearse—$9.00*
- *Three Cantors—$18.00*
- *Fee to minister—$5.00*
- *Removing remains—$7.00*
- *Cemetery Charges—$22.00*

Locally, Daniel D. Jones opened his undertaking business in 1876; he was the first in northeast Pennsylvania to embalm a body. This practice was begun during the Civil War in order to preserve the body so it could be viewed for a period of three days. Prior to the war, the deceased could only be viewed for a period of twenty-four hours.

"WATER FOR ELEPHANTS" AT THE NAY AUG ZOO

The Nay Aug Park Zoo was officially opened in 1920; four years later, the children of Scranton held a citywide fundraiser by collecting change in order to purchase an elephant. Queenie, the first of the zoo's four female Asian elephants, arrived in June 1924. Queenie was a crowd pleaser and entertained her visitors until her death in May 1935.

Following Queenie's death, another fundraiser was launched, and Tillie was purchased from a wild animal farm in New Hampshire along with her adorable sidekick, Joshua the donkey. In 1938, the zoo built a new enclosure for her and Joshua. One year later, Tillie was diagnosed by Larry Davis of Ringling Brothers and Barnum & Bailey Circus with a cold of the kidneys (better known as a kidney infection) due to the concrete flooring of the enclosure; it was then replaced with wood, and Tillie made a full recovery. Tillie, dubbed the "dancing elephant," would treat her fans to her own version of a soft shoe, while Joshua looked on. Sadly, Tillie's longtime companion passed on in 1958. In February 1966, it was reported that Tillie slammed Nay Aug's zookeeper into a wall with her trunk. It was never known for certain if Tillie's aggressive behavior was due to her infected, abscessed feet, but most suspected so. Tillie was euthanized later that year.

A bear cub at the Nay Aug Park Zoo. *Author's collection.*

Princess Penny made Nay Aug Zoo her home in September 1966; she was only a baby when she arrived, but her stay was short-lived, as she died less than five years later due to extensive bloating.

In the summer of 1971, Scranton held its fourth and final fundraiser to replace an elephant for the Nay Aug Park Zoo. Toni was purchased from the Children's Zoo in Iowa. She was small in size; at her peak, she weighed in at 6,500 pounds. Toni was transferred to the National Zoo in 1989 upon the closing of the Nay Aug Park Zoo. Toni passed away in 2006 from an injury to her left front leg that she sustained during her stay at Nay Aug.

SCRANTON'S PARANORMAL PHENOMENA

In 1919, Godfrey Raupert, a former member of the Society for Physical Research, gave a lecture at Marywood College on Spiritualism. Raupert was considered to be a worldwide authority on the subject.

Spiritualism is a system of explanation of certain phenomena, having the general belief in the survival of the spirit after death. Even though there are many similarities between Spiritism and Spiritualism, they do differ in some ways, particularly regarding a person's quest toward spiritual perfection and the manner by which they practice the belief. Also, unlike Spiritualism, Spiritism is not a religious sect but rather a philosophy or way of life.

During his lecture, Mr. Raupert stated that it is now impossible to deny the existence of spiritistic phenomena. However, these spirits do not come from God. Raupert went on to attempt to prove his theory in several ways. First, the spirits falsely impersonate the dead. They deny Christ and Christianity. He also warned the audience about dangers of the Ouija Board. At first, he explained that the messages may be recognized as coming from one's own mind, but as the spirit obtains fuller possession of the mind, messages come through that are unknown by the operator. The more frequently one uses the board, the more possession the spirit gains of the subconscious mind until the operator is no longer in control.

"Spiritism is not a new thing," concluded Raupert, "but a revival of pagan necromancy which Christianity abolished wherever it carried its light of faith and civilization."

Scranton hopped on the "paranormal" bandwagon during its revival in the mid- to late nineteenth century. If you were looking for a message from the Great Beyond, you didn't need a Ouija Board; all you had to do was let your fingers do the walking. In Scranton's city directory for 1891, you will find listed in the business section "Fannie W. Sanborn, Clairvoyant." The word itself means "clear viewing." A clairvoyant is said to have the gift of insight, and Ms. Sanborn had quite a following. Her name appears in the city directories until 1919.

The "Great Houdini" came to Scranton many times during his career. He performed at the famed Poli Theatre on Wyoming Avenue to standing room–only crowds. During one of his appearances, a Scranton patrolman went to the stage to place handcuffs on Houdini that the policeman had specially made for the escape artist. After he locked them on Houdini, he remarked to fellow officers, "He'll never get out of them cuffs." Only a few seconds passed before the magician walked over to the cop and said, "Here's your handcuffs. I thought you might want to show them to the boys at headquarters." The audience broke into wild laughter over the stunt that flabbergasted one of Scranton's finest.

Houdini made exposing fake spiritual mediums his life's work. After his beloved mother passed away, Harry spent years and much money on mediums in an effort to contact her one last time. But it was not meant to be. According to many sources, Houdini wanted to expose every fake medium who went around taking money from unsuspecting people.

Scranton Times Is Dead

No, not the newspaper—rather, the "Best in Show" champion Boston terrier owned by Mrs. Henry Schleining of Scranton. The year was 1940 when the popular pooch succumbed to heart disease. At the height of his career, the son of Royal Oak, from well-known Thordy Kennels in Michigan, took the dog show circuit by storm. This little guy was only seven weeks old when the Schleining family gave the pup a home and named him after the popular newspaper. "S.T.," short for Scranton Times, and his half-brother, Burger's Rex, both won blue ribbons at the eighth annual dog show of the Lackawanna Kennel Club. He won best of his breed eight years in a row and captured top titles in other regional dog shows in Reading, Wilkes-Barre and numerous cities up and down the East Coast.

Scranton Times was a member of the American Kennel Club, which was established on September 17, 1884, by a group of twelve sportsmen. Each of the twelve were delegates from various dog clubs that had hosted at least one dog show in the past. The AKC was the "Club of Clubs," and Scranton Times and his family were proud of the pooch's membership.

The champion Boston terrier had been in wonderful health until he reached thirteen. First his eyesight began to go and then his heart. At the time of his death, Scranton Times left behind a son, named Scranton Times Jr., to carry on the family's championship spirit.

CITY ASSESSOR ACCUSES WIFE OF INFIDELITY

Philip Rinsland was not originally from Scranton. He was born in Callicoon, New York, the son of a locomotive engineer. His father died in a railroad accident in Carbondale when Philip was only five years old. As a young man, Philip worked as an apprentice in John Wahl's barbershop on Lackawanna Avenue. Some years later, he opened a shop of his own called the Turkish Bath Barber Shop on Linden Street.

Rinsland threw his hat into local politics in 1899 and was elected to the position of city assessor. He has been described as having a keen eye for poor conditions in the city. He helped develop many sections of the city, most notably the Roundwoods in West Scranton. He served as assessor for many years and under several different mayors: James Moir, W.H. Connell, Alex T. Connell and John Von Bergen. It was during Von Bergen's term that he was appointed to inspector of dairies and watersheds.

Philip married Miss May Williams in 1892. The couple enjoyed a happy marriage at first, but while his career was on the rise, his marriage was headed for a downfall. Eight years after they said, "I do," Mr. Rinsland filed for divorce. It became one of the most sensationalized cases of its time.

In an article published by the *Scranton Times*, dated February 19, 1900, the headline reads, "City Assessor Rinsland Accuses His Wife of Being Unfaithful." The article goes on to say Edward E. Everhart, son of Dr. Isaiah F. Everhart, was named as correspondent. Rinsland claimed that his wife was seen in the company of Mr. Everhart at Crystal Lake, as well as in New York. She, in turn, denied all allegations. In addition to the divorce suit, Rinsland brought an action against Everhart for $30,000 in damages for alienating his wife's affections.

The son of Isaiah Everhart, founder of the museum, was said to be having an affair with Philip Rinsland's wife. *Author's collection.*

In 1905, with the scandalous divorce behind him, Rinsland became a member in the firm Rinsland & Jones, whose interest was in the development of the Hyde Park section of the city. He later purchased the old Nettleton property at 920 Green Ridge Street and made it an ideal home for several fraternal organizations. The building stood three stories high and was known as Rinsland Hall. It still stands today.

During 1913, Rinsland got behind the candidacy of George W. Maxey for district attorney and played a major part in his victory. Then he entered the district attorney's office and soon after was made Chief County Detective Rinsland. Because of his popularity, many people urged him to run for sheriff, but he declined.

WE TEACH THE WORLD

Thomas J. Foster, a native of Pottsville, Pennsylvania, founded the International Correspondence School in 1891. Several years earlier, Foster had worked as an editor for a small newspaper in Shenandoah. He had also been a schoolteacher and a printer. The editor for the rural mining community believed that the pen was mightier than the sword. When a

The International Correspondence School was founded by Thomas Jefferson Foster. *Author's collection.*

close friend of his was killed in a mining accident due to asphyxiation from gas, Foster picked up his pen and wrote a scathing editorial detailing the tragic events. He accused the mining company of moral irresponsibility for allowing improperly trained foremen to lead the men down into the pit of death. More editorials followed, and thanks to Foster, a law was passed that led to safer mine environments.

Many of the undereducated miners had been unable to pass a newly required test, and this made Foster very unpopular with the men. Instead of taking their protests to heart, the former teacher offered to tutor the miners and turned the newspaper where he worked into a night school. Foster developed a simple study plan for those who attended his classes, and the miners who lived a distance away were allowed to mail their answers to be checked by Foster. The International Correspondence School in Scranton was born out of this question-and-answer system.

The first year's enrollment consisted of 500 miners; nearly a decade later, enrollment had soared to more than 190,000 students. ICS was the first home-study institution of its kind, and it dominated the field, being the largest school for people wishing to learn professions and trades such as drafting, contracting, architecture and carpentry. By 1906, ICS offered more than five hundred different subjects. The school's motto, "We teach the world," was known around the globe. It is also credited for standardizing the practice of putting a return address in the upper-left corner of envelopes.

Today, the International Correspondence School has become the Penn Foster Career School, and it operates on a smaller scale. Penn Foster offers high school diploma programs and certificates in other fields, including bridal consultant, desktop publisher, home inspector, pet groomer and webpage designer.

In 2001, Thomas J. Foster was elected to the Educator Hall of Fame.

WHO YA GONNA CALL?

Over the past several years, television shows chronicling the paranormal have popped up everywhere: *Ghost Hunters*, *Paranormal State* and *Ghost Adventurers*, just to name a few. But ghost hunting began long before the Roto-Rooter plumbers by day/ghost chasers by night duo of Grant and Jason.

In 1848, two young girls living in Hydesville, New York, began hearing strange noises in their home. Twelve-year-old Katherine Fox tried to make contact with their invisible visitor by challenging "it" to a game. Katherine would snap her fingers several times, and the unseen houseguest would repeat the number of snaps with knocking. Neighbors bore witness to these knockings, and news of the unexplained phenomenon spread from town to town like wildfire. The spiritual movement was born, a mystical belief system that included life after death and the ability to communicate with the dead. Thanks to Katherine and Margaret Fox, this period in American history made séances, tarot card readings and sessions with the Ouija Board favorite pastimes conducted in family parlors.

Eventually, the Fox sisters became celebrities in their own right, highly sought after by the social elite for the chance to communicate with the spirit world. With their popularity at an all-time high, the sisters toured music halls, giving paranormal performances both in the United States and abroad. Many skeptics tried in a variety of ways to expose them as frauds. By the late 1880s, the sisters had begun to quarrel and overindulge in alcohol; some reports claim that they grew tired of the act and exposed themselves by confessing that the source of the "spiritual knocks" during their performances were their toe joints, which they were able to crack loudly at will. But there were still many who wanted to believe that the sisters' act was real. Katherine died in July 1892, and Margaret followed in March 1893. Despite their fame, they died penniless.

The United States had the Fox sisters, and Europe had the Ghost Club, founded in London in 1862. It is the oldest paranormal society in the world. This club was organized to investigate paranormal research and to swap ghostly tales among members, who included Charles Dickens and other famous figures in history.

Lackawanna County has several locations that have reputations for being haunted and are favorite hot spots for ghost hunters:

• Andy Gavin's Pub. This building on North Washington Avenue dates back more than one hundred years. George, a nineteenth-century miner, is said to have made his presence known from time to time. George likes to turn the lights off and on, move objects around and touch the customers, especially their hair.

• Houdini Museum. No, it's not Harry himself haunting the halls of the North Main Avenue establishment. Instead, tales of murder/suicide and rumors of the building being built over an Indian burial ground are said to be the source of its paranormal activity. Perhaps Chief Capoose will make an appearance at the next séance.

• The Scranton Trolley Museum. According to one spooky local legend, the museum includes a passenger whose spirit is trapped at the rear of car no. 46. Reports range from a presence being felt to items moving on their own and whispers being heard out of nowhere. Psychics who visited the museum sensed the presence of a lonely woman sitting in the car.

• At an undisclosed location in Taylor, there have been reports of people hearing ghostly voices calling their names when they were alone in the building.

One last local legend involving ghosts began in the 1800s, when mysterious lights were seen in the sky of Lackawanna County. They seemed to be centered mainly over Archbald, and there were more than one hundred reports from people claiming that they had seen the lights floating over their homes and other locations. Some theorized that the eerie lights were those of the ghosts of people who died tragic deaths, but the theory was never proven to be fact.

WHAT A DAY FOR A KNIGHT

More than three thousand Knights Templar gathered to participate in a parade held on May 23, 1959, in downtown Scranton. The parade was part of the festivities for the Eighty-sixth Conclave of the Grand Commandery of Pennsylvania. Crowds of people lined Washington Avenue on the beautiful spring day and watched in awe as members of the Corinthian (Chasseur) Commandery, No. 53, of Philadelphia, the only mounted unit in the order, executed a drill in front of the bandstand. Once the parade concluded, the members gathered at Norman Hall in the Masonic Temple to start the conclave.

The portrait of a Templar Knight from Scranton. *Author's collection.*

The history of the Knights Templars began after Christian fighters captured Jerusalem during the First Crusades. Many pilgrims began visiting the Holy Land and were killed while crossing through Muslim-controlled territory. In 1119, a French knight named Hughes de Payens founded a military order and called it Poor Knights of the Temple, later known as the Knights Templar. Their mission was to protect Christian visitors to the city.

GRAVITY

Once anthracite coal was discovered as a method for burning fuel, shipping the product to market became an issue; there were only two small railroads in operation at this time. At first, the Wurts brothers concentrated on getting the coal to the Philadelphia market, but they soon realized that they would make more of a profit with the New York

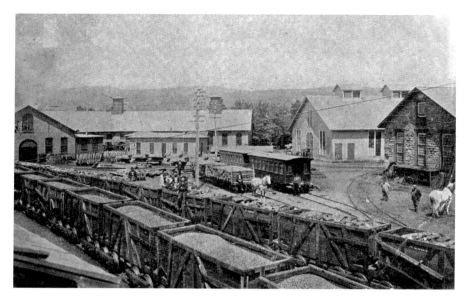

The gravity railroad put Carbondale on the industrial map. *Author's collection.*

Market. Maurice Wurts set up a meeting with Phillip Hone (who would later become mayor of New York, as well as the namesake of Honesdale), and arrangements were made.

Work began on a canal running from New York on the Hudson to the Delaware in July 1826. It was extended to Honesdale two years later. From there, a gravity railroad was built to the mines in Carbondale, and operations began in 1829. By 1833, eighty-four thousand tons of coal were shipped via the gravity railroad to Honesdale.

The gravity railroad was the industrial awakening in the valley, and within a few years, Carbondale had become the second-largest town in what was then Luzerne County.

WQAN

On January 8, 1923, WQAN hit the airwaves. The *Scranton Times'* first AM radio station was known as the "Voice of the Anthracite." Pioneer radio engineer Adolph Oschmarn helped establish the radio station, owned by the Lynett family. Tom Nealon was the official announcer in those early days of radio; he was also a reporter for the newspaper.

WQAN originally broadcast at 1070kHz, but in 1925, the frequency was changed to 1200kHz. It changed frequency several times through the years. WQAN and WGBI shared a frequency until this ended in 1948. That same year, a tower was built on the *Scranton Times* building for the new WQAN-FM at 92.3 on the dial; it moved the AM station to 630 AM.

The 1950s brought another big change for the station: the call numbers were changed to WEJL-FM. In 1955, the station went silent, and the AM station took over the call letters and became WEJL.

WQAN radio tower high atop the *Scranton Times* building. *Author's collection.*

UNICO

The Scranton chapter of Unico National was organized in 1955, thirty-three years after the first chapter, which was formed in Waterbury, Connecticut. The Scranton chapter is the largest in the country and heavily involved with community service.

The local chapter is best known for the major role it plays in planning La Festa Italiana, the annual Labor Day weekend festival held around the courthouse square in downtown Scranton. But for more than fifty years, the chapter has contributed to both local and national charities. It provides scholarships for students to attend the University of Scranton, Marywood University, Penn State Worthington Campus, Lackawanna College, Keystone and Johnson College. It is proud of its Italian heritage, and to ensure its preservation, it set up an endowment program on Italian culture in order for it to be taught at the Penn State Campus in Dunmore.

Members of the local chapter of Unico.

In 2013, the Scranton Unico raised funds needed to construct "St. Francis Commons," a housing project that serves homeless veterans. Many of Unico's members are veterans who fought and sacrificed for their country. Dr. Benjamin Cottone, Alfred Dante Jr. and Christopher Di Mattio all served as Unico presidents throughout the years.

RETURN TO SENDER

As Scranton grew in leaps and bounds, so did its postal system. By the turn of the century, the city's post office was on the list of the fifty greatest post offices in the country. The first facility in the area was established on January 10, 1811, at Slocum Hollow, then called Unionville, and Benjamin Slocum was the first postmaster.

The growth of Carbondale, brought on by the coal mines and the gravity railroad, made mail routes a necessity. In August 1829, a post office was established in the Pioneer City, and John W. Goff was named postmaster. By 1843, Carbondale was receiving mail four times a week.

The Blakely Post Office served the entire Mid-Valley until 1847, when Archbald established its own facility. Ransom had to depend on Pittston for

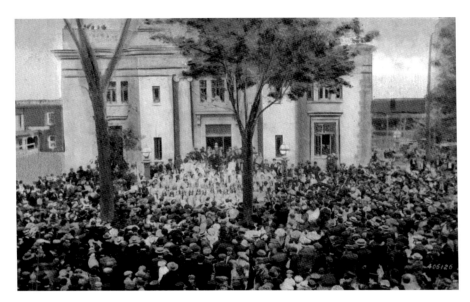

The Carbondale Post Office was established in 1829. *Author's collection.*

mail service for a time; finally, a post office was established there in 1849, in Newton in 1844 and in Dalton in 1854.

David Dale, an early settler in Daleville, was the village's first postmaster. The date of the establishment is unknown. Jay Gould, railroad magnate, Wall Street financier and namesake of Gouldsboro, was first postmaster there. He was also the owner of the Gouldsboro Tannery. The postal facility was established in 1856.

As a little-known fact to conclude with, postage and envelopes were introduced in England in 1837 by Rowland Hill. They did not come into general use until 1850.

THE MELTING POT

Many immigrants flocked to this region due to the opportunities that our large industries offered them. Entire families would toil from morning until night to achieve the American dream. Boys as young as seven would work in coal breakers, and girls would help put food on the family's table by working in the silk mills.

But there were those immigrants who came to America and turned their story from rags to riches, as in the case of the Lynett family. William

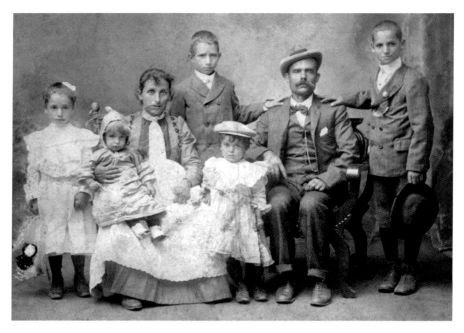

The Hresko family left their homeland of Austria-Hungary and came to America in 1901. *Author's collection.*

Lynett was born in County Sligo, Ireland, in the 1820s. He came to America when he was sixteen years old and resided in New York for a time before moving to Dunmore. He lived in the borough for more than fifty years and enjoyed success as a mining contractor. His son, Edward J. Lynett, made a notable name for himself as the editor and proprietor of the *Scranton Times*, one of the most influential newspapers in Pennsylvania.

Charles C. Battenberg came to the States from Hofgeismer, near Cassel, Germany, and settled in Archbald, where he was in the employ of the Delaware and Hudson Company. He worked hard and eventually rose to the position of superintendent of its colliery.

William J. Davis lived the first seven years of his life in his native land of Ireland. Davis arrived in Scranton in 1896 and opened a merchant tailoring establishment in the old Frothingham Arcade. He was a notable tailor in the city, and later he opened another store in the Bliss-Davis Building on the corner of Adams Avenue and Spruce Street. He and his business partner, Valentine Bliss, developed a large section of real estate on the east side of the city.

All those who came to Lackawanna County from other countries made their marks through hard work and dedication in order to make a better life for their families.

MERRY CHRISTMAS, ELECTRIC CITY!

'Twas the night before Christmas
 And all through the city

The twinkling lights on Lackawanna Avenue
 Look oh so pretty

Last-minute shoppers hustle from the American Auto
 To the Scranton Dry

While visions of "Sold Out" signs
 Greet their horrified eyes

You in your Central cap
 And I in my Scranton Tech coat

Go from store to store
 Refusing to give up hope

Down Lackawanna, over North Washington
 Up Spruce to Wyoming

In Kresge's, out Woolworths
 This is starting to get boring

Next Fannie Farmers and Spruce Records
 All this rushing around is making me dizzy.

Samters, Salbens, Thom McCanns, Lewis & Reilly
 Which one of those is "Always Busy"?

More dead ends and that's not it
 We were about to call it quits

When out on Wyoming Avenue should appear
 A man dressed in red with a pearly white beard

He spoke not a word
 And nodded his head with a jerk

And there in the Globe Store's window it sat
 The Red Ryder BB Gun Like Ralphie's
 "Oh Snap"

I turned to thank him
 But the man in red had taken flight

And then I heard him exclaim as he turned up Lackawanna
 "Merry Christmas, Electric City, and to all a Good Night"!

He paused, then turned back with one last shout
 "Remember kids, don't shoot your eye out"!

BIBLIOGRAPHY

BOOKS

Booklet Committee. *First Hundred Years: Jermyn, PA.* Scranton, PA: Scranton Public Library, 1970.

————. *Jessup Centennial, 1876–1976.* Scranton, PA: Scranton Public Library, 1976.

Builders of Scranton. Scranton, PA: Roy W. Andrews and Associates, 1941.

Craft, David, William A. Wilcox, Alfred Hand and J. Wooldridge. *History of Scranton, Penn., with Full Outline of the Natural Advantages, Accounts of the Indian Tribes, Early Settlements, Connecticut's Claim to the Wyoming Valley, the Trenton Decree, Manufacturing, Mining, and Transportation Interests, the Press, Churches, Societies, Etc., Etc., Down to the Present Time.* Dayton, OH: United Brethren Publishing House, 1891.

Dickson City Centennial Committee. *Dickson City Centennial, 1875–1975.* Dickson City, PA: Dickson City Centennial Committee, 1975.

Floods of 1942: Hawley, Honesdale, Carbondale, Archbald, Olyphant, Dunmore, Scranton. N.p., n.d.

Hitchcock, Frederick L. *History of Scranton and Its People.* Vols. 1 and 2. New York: Lewis Historical Publishing Company, 1914.

Hollister, H. *History of the Lackawanna Valley.* 6th ed. Scranton, PA: Tribune Publishing Company, 1903.

Logan, Samuel C. *A City's Danger and Defense or, Issues and Results of the Strikes of 1877, Containing the Origin and History of the Scranton City Guard.* Scranton, PA: Samuel C. Logan, DD, 1887.

McKune, Robert H. *Memorial of the Erection of Lackawanna County, in the State of Pennsylvania: Comprising an Account of the Progress of the New-County Movement, the Laying of the Corner-Stone of the Court-House and a Steographic Report of the Speeches at the Banquet Held.* Cranberry Township, PA: Bookeeper Preservation Technologies Inc., 1997.

Mumford, Mildred. *This Is Waverly.* Waverly, PA: Waverly Woman's Club, 1954.

Murphy, Thomas. *History of Lackawanna County Pennsylvania.* Vols. 1 and 2. Indianapolis, IN: Historical Publishing Company, 1928.

The Passionist Fathers. *Saint Ann of Scranton.* 11th ed. Scranton, PA: Manus Langan Press, n.d.

Rashleigh, Alice Voyle. *Carbondale Centennial, 1851–1951.* Scranton, PA: Scranton Public Library, 1951.

Stephens, J.B. *History and Directory of Newton and Ransom Townships, Lackawanna County, Pennsylvania: Including a History of the Wyoming Valley, and a Brief History of Pennsylvania and Lackawanna County. Also Many Biographical Sketches.* Montrose, PA: J.B. Stephens, 1912.

Throop, Benjamin H. *A Half Century in Scranton.* Scranton, PA: Benjamin H. Throop, 1895.

Weyburn, S. Fletcher. *Origin and History of the Famous Archbald Pot-Hole: Archbald, Lackawanna County Pennsylvania.* Scranton, PA: S. Fletcher Weyburn, 1929.

ARTICLES

A special note regarding Our Town *articles: They make up a large part of this book and are not listed individually for interest of space, but back issues can be obtained by contacting Josh (OTLC11@yahoo.com). Information used for some of the articles was acquired through obituaries and family histories taken from the Forest Hill Cemetery archives and are too numerous to list here. To get more information on individual people, contact Norma Reese, Forest Hill Cemetery, 1830 Jefferson Avenue, Dunmore, PA, 18509.*

Citizens Voice. "Army Protected Local Collieries during Railroad Strike of 1877." May 13, 2008.

Gerrity, Edward J. "This Is My Town." *Sunday Times,* January 5, 1969.

Kashuba, Cheryl. "Funeral Home at Forefront of Industry." *Times-Tribune*, June 5, 2011.

———. "Immigrants Found Opportunity in Scranton." *Times-Tribune*, March 17, 2013.

Legere, Laura. "Cardinal to Celebrate Mass on Parade Day." *Times-Tribune*, February 9, 2010.

Lowman, Marita. "President of Sinn Fein Rallies Scranton's Irish." *Sunday Times*, March 10, 2002.

Mates, Rich. "Adams Returning to Scranton for Dinner on Day of St. Patrick's Parade." *Scranton Times*, January 25, 2002.

Miller, Ethel A. "A Successful Woman in a Man's Game: Mrs. George Brown, Scranton, Pennsylvania." *Journal of Negro Life* (1930): 214–15.

Scranton Republican. "Forest Hill Suicide." November 19, 1891.

Scranton Times. "Armory." November 3, 1900. *Scranton Times*. "City Woman Receives Achievement Award." April 10, 1951.

———. "Engineer Caused Crash." July 5, 1912.

———. "Lecture on 'Spritism' at Marywood College." December 4, 1919.

———. "Marshals Appointed for St. Pat's Parade." March 1, 2001.

———. "St. Lucy's." April 25, 1907.

Scranton Tribune. "Luis Pughe." January 8, 1892.

Stephenson, T'Shaiya. "Bunnell Hardware: Then and Now." *Abington Journal*, January 10, 2011.

Sunday Times. "Dignitaries Named to Lead St. Patrick's Day Parade." March 7, 2004.

Times-Tribune. "Local History: 'Voice of Anthracite' Loud, Clear." January 5, 2014.

———. "NEPA's 'Other World.'" October 11, 2009.

Wintermantel, Kristin. "Clydesdales Arrive to Hoof It in Parade." *Scranton Times-Tribune*, March 12, 1997.

———. "Clydesdales to Stay at Globe, Appear in St. Patrick's Parade." *Scranton Times-Tribune*, March 12, 1997.

PRESENTATIONS

Azzarelli, Margo. *1877: Riot on Lackawanna Avenue.* Theatrical production, the Lackawanna Iron Furnaces, 2007.

WEBSITES AND ONLINE RESOURCES

American Red Cross. "Our History." http://www.redcross.org/about-us/history.

Ancestry.com. "Jonathan Childs Sherman." http://records.ancestry.com/jonathan_childs_sherman_records.ashx?pid=42111373.

Auction Finds. "An Undertaker's Bill for a 1918 Funeral." May 28, 2014. http://myauctionfinds.com/2014/05/28/an-undertakers-bill-for-a-1918-funeral.

Beitler, Stu. "Scranton, PA Bloom Carriage Mfg Co Fire, May 1890." GenDisasters, October 14, 2007. http://www3.gendisasters.com/pennsylvania/724/scranton,-pa-bloom-carriage-mfg-fire,-may-1890.

———. "Throop, PA Mine Explodes Near Scranton, Apr 1911." GenDisasters, April 3, 2008. http://www3.gendisasters.com/pennsylvania/6022/throop-pa-mine-explodes-near-scranton-apr-1911.

Borough of Jessup. "The History of Jessup." http://www.jessupborough.com/history.

Carbondale Historical Society. "The Hotel American." http://www.carbondalehistorical.org/Route_6_Historic_Sites.html.

Coney Island Lunch. "A Little Bit About Our History." http://texas-wiener.com/about.html#submenu.

Easley, Ryan. "Nay Aug Park Zoo, Scranton, Pennsylvania." ShowMe Elephants, January 1, 2011. http://www.showmeelephants.com/2011/01/nay-aug-park-zoo-scranton-pennyslvania.html.

Franklin D. Roosevelt Presidential Library and Museum. "On the Coal Crisis—May 2, 1943." September 15, 2009. http://docs.fdrlibrary.marist.edu/050243.html.

Gertrude Hawk Chocolates. "History." http://www.gertrudehawkchocolates.com/about-us/history.

History Learning Site. "The Battle of the Bulge." http://www.historylearningsite.co.uk/battle_of_the_bulge.htm.

Horton, Linda. "Scranton, PA Crystal Lake Drowning Rescue, Aug 1911." GenDisasters, November 20, 2007. http://www3.gendisasters.com/pennsylvania/3424/scranton,-pa-crystal-lake-drowning-rescue,-aug-1911.

Lyricsmode. "30,000 Pounds of Bananas lyrics." http://www.lyricsmode.com/lyrics/h/harry_chapin/30000_pounds_of_bananas.html.

Marywood University. "History of the University." http://marywood.edu/history/muhistory.

Morrow, Felix. "Roosevelt and Labor after the Third Coal Strike." *Fourth International* 4, no.7 (July 1943): 202–6. Translated by Ted Crawford. Marxists' Internet Archive, 2005. https://www.marxists.org/archive/morrow-felix/1943/07/coal.htm.

O'Hara, Mike. "Origins of Town Names of Northeast PA." NEPA Newsletter, August 2007. http://www.nepanewsletter.com/towns.

St. Ann's Monastery and Shrine Basilica. "History of St. Ann's." http://www.stannsmonasterybasilica.org/st-anns-history.html.

St. Lucy's Church: The Mother Italian Church of the Diocese of Scranton. "History of St. Lucy's Parish." http://www.stlucy-church.org/history.html.

Times Tribune. "Column Extra—A Masonic Parade." November 29, 2009. http://blogs.thetimes-tribune.com/pages/index.php/2009/11/29/column-extra-a-masonic-parade.

About the Author

Margo L. Azzarelli is a writer/ researcher specializing in local history. She writes a bimonthly column for *Our Town Lackawanna County*. The author of three books with Arcadia Publishing (*Taylor*, *Green Ridge* and *Old Forge and Moosic*), she writes and produces historical programs and plays, such as about the 1877 "Riot on Lackawanna Avenue," and conducts the annual Forest Hill Cemetery walking tour. Mrs. Azzarelli volunteers

for the Lackawanna Historical Society and is the second vice-president for the Triboro Historical Society. She lives in Scranton, Pennsylvania, with her husband, Dominick; her daughter, Marnie; and a houseful of fur babies.